...Wendy Beckett; contributing...

...Edward Hopper /[... dialogue preparation Francoise ...]

Edward Hopper

# EDWARD

# HOPPER

BLOSSOM

This 1991 edition published by
H.C. Blossom Ltd.
6/7 Warren Mews
London, W1P 5DJ

Copyright © 1989 Musée Cantini, Marseille
and editions Adam Biro
17 Rue du Louvre, 75001 Paris, France

Translated by Michael Edwards and Melissa Mizel
Chapter entitled "The Photosynthesis of Being"
by Yves Bonnefoy translated by Richard Stamelman

ISBN: 1 872532 79 9

Printed and bound in Hong Kong

# Acknowledgments

The idea for this exhibition grew from an invitation from the Cultural Section of the United States Embassy, which permitted Nicolas Cendo, curator of the Musée Cantini, to approach American museums. From its inception, the project benefited from the support of M. Emmanuel de Margerie, French Ambassador to the United States, and a grant from the Cultural Section of the United States Embassy in France. It could not have developed without the close cooperation of the Whitney Museum of American Art, New York, and the Museum of Modern Art, New York.

The exhibition finally took shape through the generosity of the directors and curators of the following institutions: Brooklyn Museum, Brooklyn, New York; Butler Institute of American Art, Youngstown, Ohio; Columbus Museum of Art, Columbus, Ohio; Corcoran Gallery of Art, Washington, D.C.; Hirshhorn Museum and Sculpture Garden, Washington, D.C.; Metropolitan Museum of Art, New York; National Gallery of Art, Washington, D.C.; Norton School of Art, West Palm Beach, Florida; Philadelphia Museum of Art, Philadelphia; Terra Museum of Art, Chicago; Virginia Museum of Fine Arts, Richmond, Virginia; Walker Art Center, Minneapolis, Minnesota; Whitney Museum of American Art, New York; Williams College Museum of Art, Williamstown, Massachusetts; Yale University Art Gallery, New Haven, Connecticut; as well as the benevolence of ACA Galleries, New York, and Mr. & Mrs. Carl Lobell, New York.

It could never have been realized without the scientific expertise and active support of Tom Armstrong, William S. Lieberman, and William Rubin, the friendly collaboration of Deborah Lyons, or the generous participation of Susan E. Menconi.

The *Edward Hopper* exhibition will be shown at the Fundación Juan March in Madrid. Its director, José Luis Yuste, and director of exhibitions, José Capa Eiriz, have participated actively in the project's development.

The *Edward Hopper* exhibition has received the support of the Direction des Musées de France and of the Inspection Générale des Musées Contrôlés thanks to the kind attention of Olivier Chevrillon, Alain Erlande Brandenburg, and Germain Viatte. It has benefited also from the assistance of the Museum Association of Marseilles and its president, Georges Salamon.

Léon Aget & Co. were of invaluable assistance in the mounting of this exhibition.

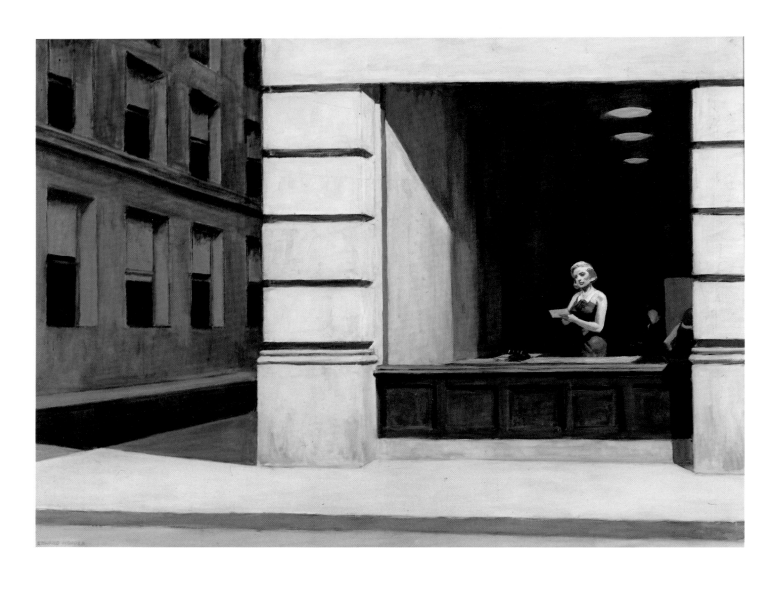

**New York Office**

1962

oil on canvas

101.6 × 139.7 cm.

For a long time, American painting has demonstrated both its autonomy with respect to Europe and a capacity for enrichment. In seeking to separate themselves from l'École de Paris and in exploring the fertile field of Abstract Expressionism, American painters have sought a profound transformation of European cultural influences.

By addressing the everyday realities of American society, the Pop Art and Photorealist movements have created a distinctive national art, one that permits other continents to discover and appreciate the sometimes violent dynamism of America's urban sensibility.

Among the giants of American painting, Edward Hopper occupies a privileged place. Indeed, this great artist was among the first to paint these everyday realities of his native America, and he did so with an astonishing force and acuity, managing to create an image of his country that has become almost mythic.

It is not by chance that Americans consider Hopper one of their great artists, and their attachment to his works made it that much harder to assemble this exhibition, which will leave Marseilles for the Fundación March in Madrid.

It was, however, most appropriate that the city of Marseilles should be the site of this event, which will enable Hopper's work, never before shown in France or southern Europe, to at last be better known to the public. It is thus that Marseilles's long-standing role as a cultural center of the Mediterranean will continue to grow.

Robert P. Vigouroux
Mayor of Marseilles

# Table of Contents

Asterisks denote works that are part of the exhibition at the Musée Cantini.

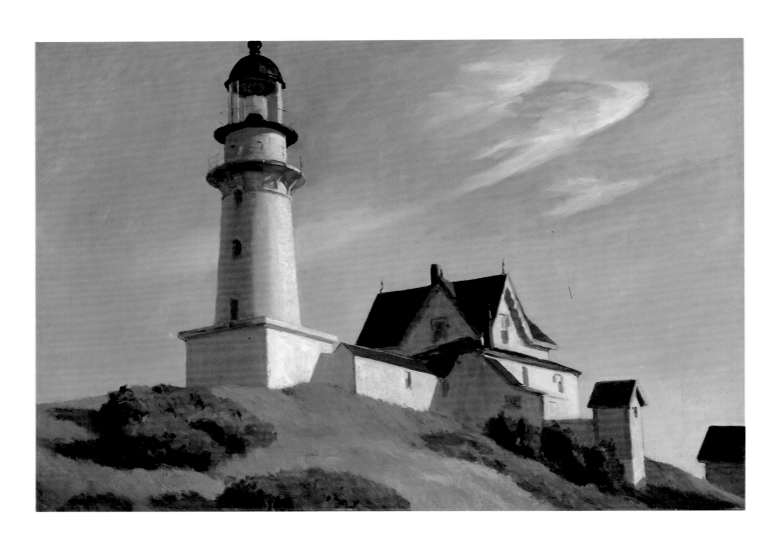

**The Lighthouse at Two Lights**

1929

oil on canvas

74.9 × 109.8 cm.

# Restrained Desire
# Under a Sharp Light

It is in the nature of representational painting to build the illusion of objectivity. That means, one goes beyond choosing the subject to gather together and unite all the details that give the work its force and inner depth, while raising, at the very moment of its unveiling, the troubling question: What is reality?

It is doubtless for this reason that representation suffers from the slightest suggestion of glibness, which exacerbates the confusion between painting and picture.

Edward Hopper's oeuvre is in this regard a paragon, for its precision takes the measure of the abyss separating one from the other.

As we follow the painter's itinerary, his determination to question the real appears in all its singularity. Dismissing the avant-garde movements that followed one after another—Fauvism, Cubism, Futurism, Expressionism, Surrealism, Abstract Expressionism—this solitary artist persevered with his favorite themes: bridges, railroads, lighthouses, motels, gas stations, bedrooms, offices, houses, barrooms, highways, store windows. In his early years, he painted the delicate, nuanced European light, particularly that of Paris. Did this light heighten his experience of the sharp and brilliant American light, which he seems to have rediscovered upon his return and sought unceasingly to show thereafter? No doubt, this shift from European to American light and the decision to pursue the latter into the often unbearable void—a pursuit that sometimes approached the quixotic—must be considered one of the keys to the moving sensibility that animates his work. This observation would nevertheless remain insufficient if not for the addition of the restrained, almost buried, human dimension in which desire, melted down and recast in his paintings, opposes ever more intensely the implacable isolation to which the world condemns it.

Whether Hopper is painting a wall bathed in sunlight, a naked woman appearing in a brightly lit bedroom, or shadows stealing across the façade of a house or a station platform, figures and forms are treated in the same fashion and placed on an equal footing in the overall composition; only the lighting determines the depth or the brightness in which they are placed. However, the almost cinematic framing of the subject and the apparent neutrality of the scene fail to distract us from the fact that as we look through a window or at the woman who appears there, or as we overhear the conversation within, sometimes the barrier—the window or the wall—disappears. Admittedly, each figure remains fixed, almost shrouded in the silence that represents an absolute and unforgiving solitude; yet we are nevertheless able to detect the menace against which they struggle and the desire that takes them by surprise. Perhaps it is the irresolvable ambiguity permeating this work that makes it so deeply moving. "Maybe I am not very human," Edward Hopper has stated. This declaration should probably be taken at face value, and his painting, ignoring all human detail, bears eloquent testimony to it. Hopper's exploration of a more brilliant light is paralleled by a new exploration of the physical world and the desire underlying it. It is an absolute desire, one with no hope of reward or spiritual redemption. Eternally remote, like this lighthouse perched on a hill at Two Lights, it tries to make itself hard and cold, so as to conceal its immense wound.

Nicolas Cendo

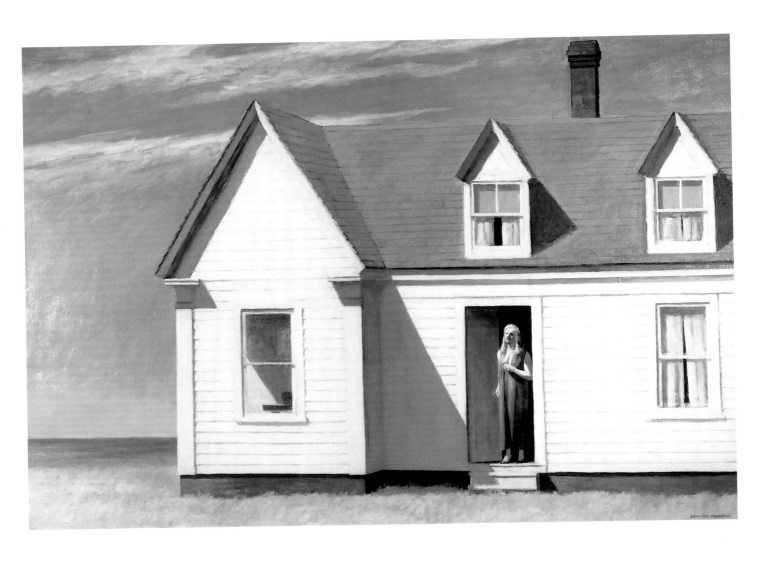

**High Noon**

1949

oil on canvas

69.8 × 100.3 cm.

# The Photosynthesis of Being

## I

Hopper's paintings before his trip to France: reddish tones mixed with orange in an oily white, painted on a dark background, as if the tangible world were a brothel where the painter ventures only by the half-light of lamps veiled in red. Evil seems an irreducible element of Being. *Man Drinking* of 1905–1906 could be the first Francis Bacon.

But what is expressed is the atmosphere of a moment and of a society. Sargent, too, used these somber colors, even on a child or a young girl. He painted on a black surface, as he was taught to do by Carolus-Duran. An aspect of the bourgeoisie, on the one hand, and of America, on the other, knowing what it owes to the values of Puritanism, come together in this rejection of the suggestions of daylight. Whether captivated by sophisticated, high culture, like a William Merritt Chase, or whether "realist" and concerned with painting all aspects of life, like the more lucid Robert Henri, the teachers at the New York School of Art, which the young Hopper attended, seem to have held their classes in some cellar of the house of Usher, behind tapestries stirred by a wind coming from beyond the grave.

Proof that this *clair-obscur* was, in the early formation of this great painter, merely the result of instruction alien to his real needs, is that almost immediately on arriving in France Hopper abandoned his "black style." Along the quais of the Seine, where the water glistens, he begins to paint works in which color seems free of any evil dream, any phantasm—works that are certainly among the brightest that any modern gaze has created. Manet and his descendants had already unfettered him through the force and truth of an art that knew how to temper its values, even ethical values, in the reality of the rising or setting sun, of the tree swaying in the light. But, all the same, could Hopper extricate himself entirely from those layers of shadow, which, surrounding the river boat he had built as an adolescent,[1] were then darkened even more by a religion in which God enters the soul without first passing through the body or nature, a religion that regards sexuality not as what unites but as what separates? Would he be better able to attain an inner maturity than Georgia O'Keeffe, nearly his contemporary, whom no New Mexico sun nor shimmering desert horizon will free from a horror of the flesh? The question is worth exploring, for it is with it that *Summer in the City* of 1949 and *Excursion into Philosophy* of 1959 are concerned: paintings of a man

or a woman engaged in painful reflection while his or her partner turns away. Not to mention, of course, the famous *Girlie Show* of 1941.

In any event, much about the power of art to conform to and accept life, to build confidence, will change for Hopper during his sojourns in Europe; and we need to stress his first great discovery of self, for henceforth it will continue to nourish him with light and determine his life. He arrived in France in 1908, at the moment when Impressionist painting and its logical continuation in the work of the Fauves, first fully recognized in 1905, had again opened the great pages of the book of nature to color. To give precedence to chromatic notations, by which preconceived ideas and the desire for narrative are dispelled, to remain outdoors in a summer's haze or under the first snowfall is to suggest a kind of symbiosis between mind and natural reality, one that offers a joy and a peace that are all the more possible considering that in the Ile-de-France or Normandy, where Impressionism took form, light is gentle; it softens shadows and helps to combat the tempting belief that evil is present everywhere and can penetrate to the very essence of life. It is precisely this conjunction of art and nature that Hopper immediately loved for the feeling of immanence it created. "The light was different from anything I had ever known," he will say. "The shadows were luminous—more reflected light. Even under the bridges there was a certain luminosity."[2] It was not an evolution, even a rapid one, which he experienced, but a sudden revolution, which replaced his skill as an already remarkable draftsman with the seemingly limitless freedom of an extraordinary colorist. The thirty or so works that survive from his three sojourns in Paris—among which there is *Le Parc de Saint-Cloud* of 1907, where even the shadows are made of light—are certainly more beautiful than anything of Marquet's whose exhibition in February of that year so excited him. The synthesis of being seems to occur now in Hopper's paintings without any residue of darkness. The result is a contented gaze, which the young painter does not represent with precision, but evokes with compassion, in either crayon or watercolor—the streets, the people encountered there, moving along, he imagines, oblivious to all gain. His pictures reflect the mood of poems to which he will remain attached his entire life. It is from *L'Heure exquise*, a small piece by Verlaine, that he will borrow the words for his diffident epithalamium, when he dreams of marrying "Mademoiselle Jo."[3]

## II

Hopper's gaze, it could be said, has been cleansed of its shadows. He owes to French painting and French landscapes a trust in light that is definitive; and in this, signs of a coming of age are seen, of an encounter with self all the more compelling in that on his return to the United States he will boldly pursue this new awareness.

It was certainly not easy for him to tear himself away from Europe, at least at the end of his first and longest trip, at an age when desire for the absolute makes the absence of what one loves most painful. He also found it disquieting to rediscover in the family house at Nyack paintings he did before his departure, with their sulfurous emanations. And what a shock now to have to perceive the world with new kinds of sensitivity and feeling! "It seemed awfully crude and raw here when I got back," he will say. "It took me ten years to get over Europe."[4] What disturbed him the most, perhaps, was that light had again become dualistic, by its violence, by too many puddles of night gleaming under stones. Nevertheless, in 1912, he paints *Squam Light*, in which he tries, not unsuccessfully, to achieve again that clear synthesis of the individual's relation to the self and to the universe, which he had learned to seek.

Let us pause a moment at this painting, recently shown at the Hirschl and Adler Gallery, because it is one of Edward Hopper's masterpieces in which his deepest desire reveals itself in a way that seems to me transparent. First we will take notice of the two civilizations that the painter has now experienced. In France—and the works of Monet or Pissarro would have taught him this, had there been need—the village houses, which are made of stone, the roads around them, which conform to the ground's unevenness, and the gardens, which press against them with walls as old as time itself, beneath trees laden with fruit, constitute first and foremost a *place*, more real than the lives that follow one another in ineluctable succession. At every moment, this place is a center of the world, reassuring to those who inhabit or approach it, and thus there is no need to make of these things—which invite one into Being—the metaphorical projection of a feeling of exile or anguish, as had been the case with Munch, for example, who gave eyes to the facades of buildings because they shared his solitude. A peasant society, sheltering its life in the eternity of stone,

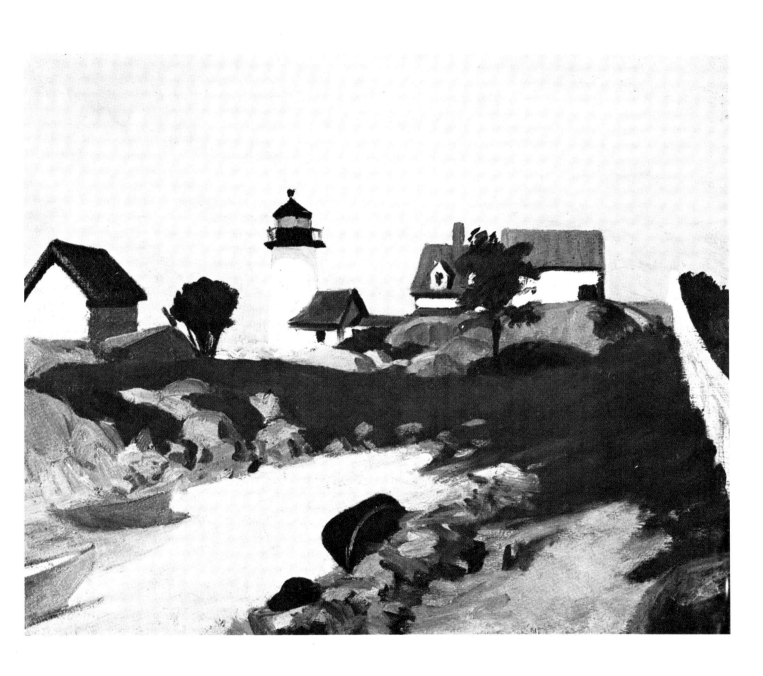

**Squam Light**
1912
oil on canvas
61 × 73.70 cm.

long dissuaded French painters from becoming interested in Expressionism.

But along the Hudson or in New England, the houses are made of light wood; you would think they had merely been dropped on the grass and could easily be moved. Their bright colors, often freshly repainted, with those beautiful objects they sometimes reveal behind shining windowpanes, are alien to the world around them much more than they are part of it. In this opposition between human life and the world's being, these graceful homes, and the small lighthouses on nearby coasts, intrepidly projecting their reclusive messages into the night, reflect the individual more than his place of dwelling. It is easy to see how we ourselves exist at the edge of a nature that remains separate, the more so as our century of longer and longer roads and of railways extended into new lands has caused houses—their windows reflecting the setting sun—to be spread far and wide into regions sometimes still sparsely inhabited, and from which all idea of a center has vanished.

Are they illusions, these vague impressions, these fleeting investments of consciousness in the representations formed? But what is a painter, if not one who, even in the most fleeting perception of a tiny patch of blue over a roof at the moment the sky clears, unites his deepest dreams and his most tangible sensations? And as for Hopper, he was sufficiently melancholic, sufficiently prey to the fear born of a simple feeling of space, so that, on his return from Europe, he was struck by the *other* status of places—the *other* symbolic potentiality of buildings and sites in the dialogue between the *I* and the transcendence of the world. The proof is found in his taste for long automobile trips: those wanderings through a landscape where in the rearview mirror rise up, before disappearing forever, the visibly precarious houses and places, which the invention of the automobile helped to spread westward, far from the Concords or the Litchfields or even the Nyacks of the past. Indeed, by around 1910, the time of the painters of the Hudson River School—who had set up their easels in places so lonely that they could have imagined being in Paradise, like Thoreau at Walden Pond—had come to an end. Henceforth, the American artist would no longer enjoy this quietude, this metaphysical peace of mind; he now ventures forth to places where life will be a struggle. And so this feeling of abandonment is conveyed, this terror before the simple fact of being, which grabs us by the throat when we pass by houses like the one in *The House by the Railroad* of 1925, that icon from which all divine promise has vanished.

Hopper was also interested—this will be the subject in 1923 of one of the watercolors that will make him known—in mansard windows, which he sees as perpendicular to the roof, surrounded by shutters, and set beneath a broken gable, all of which fill them with hollows and disquieting shadows; these windows attract him all the more because what is "mansard" in America is also in exile. In short, he has existentialized the American habitat, turning the houses in his work—houses to which we are not allowed entry, yet another sign of their affinity with this taciturn artist—and the paths and the boats on the shore into representations of his own being, as it faces a world which seems like emptiness but is, nevertheless, light. And from this, a veritable art springs forth, that of *Squam Light*.

The starting point of this work was Hopper's perception that the houses, the roofs, the two or three boats, the lighthouse were aspects of his own self; he, therefore, perceived their color, suddenly intensified by a clearing sky, as the direct contact of his innermost being with light, and could love the relations of harmony among colors and the beauty born from their intermingling. This is the proof of his own acceptance of all aspects of life, of his own unity now regained. Henceforth, artistic work will consist in understanding this harmony as deeply as possible, in letting it penetrate the mind—where it is still only abstraction, the fear and the play of fantasies—and in convincing himself that matter is light. By means of the color he puts on the canvas, which becomes precision and intensity simply through hearing and assimilating the mysterious beauty of the world, the painter is able to bring about his own transmutation. He can thus recompose his psychic being, turning his earlier anguish, born from doubts about the value of the physical world, into these pigments that are ablaze with joy. In this respect, *Squam Light* succeeds. The proof is in the heightened exchanges of colors and values, and in this little red chimney which seems more an act than a thing, more a thought than an appearance, so lively is its joyous conversation with the colors around it. If a "little patch of yellow wall" in Vermeer can satisfy one's thirst for the absolute and enable the man who loved it to die,[5] then this little patch of red brick restores the taste for living and reveals a Hopper reconciled and redeemed.

In his Paris paintings Hopper had learned what there is about light that is accessible and liberating. But that was in places having nothing to do with his life to come: on the quais, around the buildings (Notre-Dame or the Louvre) with which he had no real bond. As a result, his synthesis of being remained a dream, leaving in its wake no residue of darkness, but, conversely, failing to reach the deepest layers of his own consciousness: the childhood memories where Oedipal shadows stagnate. But now, in America, Hopper is much more truly involved and, consequently, capable of becoming, of finding himself; he is a dismembered Osiris made whole again by the grace of painting: thus better able to encounter painting's rich new possibilities and to understand its profound new needs in the historical moment. From this point of view it may appear that Hopper, by projecting himself into what he could have simply seen and represented, has adopted Expressionism, a movement that has weakened sensory experience and thus wasted the careers of many painters. However, in these landscapes he succeeds in surpassing Expressionism, for, here, each painted thing makes him relive his former drama—with its power to arouse multiple fantasies—by resolving it through the happiness this thing finds in being itself. This is an experience of the identification of appearance with being, profoundly influential in the deepening of painting, which needs for the real—in its simplicity, which is also its infinitude—to take precedence over the imaginary

"What I wanted to do," Hopper said, "was to paint sunlight on the side of a house, on a roof."[6] By means of such an experience, so intensely lived or at least desired, *Squam Light* negates the temptation to remain within the space of unconscious determinations, among the nocturnal images of a troubled moralism, to which the paintings of his apprenticeship showed him succumbing. It is the return of consciousness to this open air of the world that art must take as its dominion. And if Hopper has heeded the lesson of Impressionism and of the Fauves, just as important, perhaps, in these years of his return will be his desire to use his new knowledge in the new circumstances, by no means quite as favorable, and even to take advantage of this changed sky and these lost mediations to be open to that tangible world Monet had no difficulty finding. This is the aim of a settler, of a pioneer in a virgin land, a specifically American aim, which might well have resulted from Robert Henri's instruction: a teaching that Hopper, distinguishing Henri's philosophy of education from his style of pedagogy in the studio, summed up by the words "courage" and "energy."[7]

### III

In *Squam Light* and other landscapes painted in the years following his return, was Hopper able—using his gifts and his enthusiasms as a colorist, which kept him close to the vivid unity that each minute of the world's light reveals, and his "courage" and "energy"—to create the alchemy that Amercian culture awaited, troubled as it was by moral anxiety and paralyzed by too great a respect for European museums yet wanting to establish the identity of places and to give meaning to horizons? And did French painting merge in *Squam Light* with something taken, for example, from the Shaker colonies—which had its own painters and poets at the threshold of mystical experience—thus giving rise to what one could call the first truly profound realism since Constable or certain sketches by Delacroix, a realism that in a single impulse of the mind would express the infinity of natural things and the transparence of the heart? Although it may be true that everything in this painting reflects the painter, there are no human beings—only a few empty boats. And this characteristic is repeated in all the landscapes that will follow until 1919. Might these advances be in each instance merely the truth of a moment in which all of Hopper's personal problems and concerns have not yet appeared? Does one cease suffering from melancholy because in the field of a painting one has been able to foresee the conditions and paths of a return to the world?

In any event, there are signs that do not augur well for the future. First, there is the fact that on his return to New York Hopper resumes his job as a commercial illustrator. In this occupation he will create figures that are schematic and impersonal at a time when his drawing abilities could have been better used to represent human intimacy that would fight a propensity toward loneliness. Second, there is the fact that in 1915 Hopper begins to make etchings, an art at which he will work for several years before abandoning it (in 1923, a happy moment in his life) in order to return to watercolor and outdoor painting. Etching is the absence of color; it deprives light of its points of reflection. It was for Hopper a way of encountering the human presence of others (noticeably missing from his major work since his departure for France), but

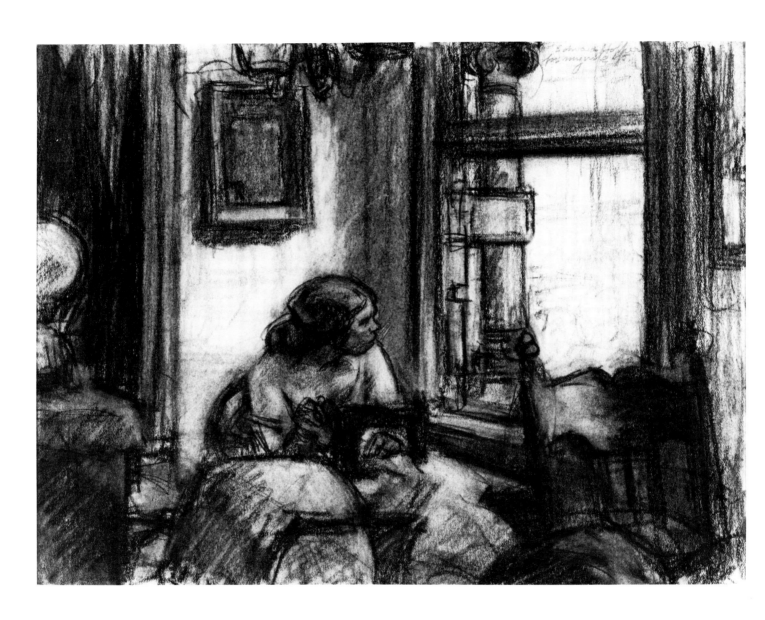

Drawing for etching
**East Side Interior***
1922
black Conté crayon and charcoal on paper
22.7 × 29.21 cm.

only through a line inscribed among black shadows without the resources of joy and balance that had been guaranteed by the open air. This is how one can find oneself again in a "mental" space, dominated by the old problems. The series of subjects Hopper tackled in his etchings certainly confirms that this technique allowed him to express obsessions and anxieties which, until then, he had not wanted to, or had not been able to evoke, except, perhaps, and then only fleetingly, in *On the Quai*, a crayon drawing of a body pulled from the Seine.

Such subjects are found, for example, in *Evening Wind* of 1921 and *East Side Interior* of 1922, two images of a young woman who seems afraid, as she stares at her open window. In the first, she is on her bed, naked and alone, and the wind has raised the window curtain, allowing entry to the bird who cries "Nevermore." In the second, it is Vermeer's lacemaker—Hopper had seen the painting in the Louvre—who, now a simple dressmaker working in a gloomy room on more mechanical tasks, is torn from her labor by an event outside, which is, at its most profound level, the sudden syncope of color. These works, and such others as *Night in the Park* or *Night Shadows* of 1921, express loneliness, but less in relation to other human beings—for example, *Night on the El Train* of 1918 brings together two people who seek comfort in one another—than as a reaction to this nocturnal world, rustling with evil forces, which one might have thought all but forgotten.

And, what is more, these etchings become paintings that give the lie to the landscapes: for instance, *Girl at Sewing Machine*—the same dressmaker, the same sewing machine—which in 1921 marks a decisive moment in Hopper's destiny. "After I took up etchings, my paintings seemed to crystallize," he once remarked.[8] And he meant it, because etching freed his drawing from the traps of the poster and the magazine cover, allowed it to return to the regions of his unconscious, once repressed by color, in which he was able to find themes that had deprived the colorist's work of all that had been learned in the "open air." And yet, in *Girl at Sewing Machine* it is a beautiful summer day. We are in New York, as the window's yellow bricks indicate. The hours seem to pass by peacefully, with the unbroken sound of a ticking clock; but something altogether different is at work here. What is it that remains of the natural world, if not light, which, having been reduced to itself, signifies only its own transcendence? Consequently, the only mediation remaining between the soul and this renewed, possibly divine, presence is that of humble, patient work, a fine Puritan value. It

is because she gives herself to the moral law that this young girl is not yet the girl of *East Side Interior*, who watches in terror as an abyss opens beside her. But what does she get in return? Primarily, a life of monotony and loneliness. Beneath the level of color, the true mood of this painting is psychological or, rather, existential. And the very intensity of this yellow and this orange-red, in fact, only make more startling, more disturbing, the way the window filters out the world's realities.

This painting is by no means an isolated example in Hopper's work, but, rather, the first in a long series of carefully considered compositions, where the process of filtering will continue to shine its silent light on scenes fraught with what seems to be hopeless expectation. In *Sunday* of 1926, another incunabulum of this new period, we can almost feel ourselves out in the "open air" with this man who is seated on the edge of a sidewalk in the classic pose of melancholy; but the reduction of the world's physical presence has already occurred through the abstraction of urban space: these store fronts pressed together and deserted where light falls as at the bottom of a well. And even in scenes that preserve some of the sky, a few trees, a little of the sea's blue, the filtering is just as strong, either because there is too much sun or because twilight shadows transform things into the characters of a drama: for example, *Seven A.M.* of 1948 or *Road and Trees*, painted near the end of Hopper's life. A new art has appeared, and it is certain that it will call into question the hopes and the victories symbolized by *Squam Light*. It was as if the resources provided by the open air of Impressionism had begun, around 1921, to dry up. "It took me ten years to get over Europe," Hopper once observed.[9]

IV

What is it that characterizes the works that from 1921 to *Chair Car* in 1965 marked the course of Hopper's destiny? First, the presence of the human being, not found in the landscapes. But is there really a presence? These men and women who, whether standing or seated, appear immobile, who look into the distance or at nothing at all, are not in any way identifiable people, individuals who have names and who might have lived in the world beyond the painting. Restraining his powers of observations of emotional matters, as he has already sacrificed much of his ability as a colorist, Hopper eliminates from his

numerous preliminary drawings anything that might attract him to the person who is posing; he reduces him or her to those very general characteristics only barely indicated by clothing or context. His personages become figures closed in on themselves; they resist our desire to penetrate their silence.

And this certainly explains Hopper's abiding interest in Degas, who also is blocked by what is secret and completely other in the person one looks at; but therein lies their difference, because Degas stops questioning the model only after he has studied him or her in all accessible aspects—which accounts for some wonderful portraits. Only when he can attest that a human being is truly there behind his or her physical self does he acknowledge the reality of non-communication and loneliness, does he speak sadly of the sadness of lonely people. Proof of this can be found in the way Degas crops his scenes. To leave out of a painting a part of the body, of a head even, is to signify that the model has emerged from a world that is his or her own and to which he or she is going to return, thus transcending all explanations offered by painters who want the model entirely on the canvas, enveloped from head to foot in the web of their signs. Degas respects and asserts the inner being of the person with whom he feels a very deep bond.

Not so with Hopper. Owing perhaps to a Puritan shyness about identifying a being with its sensual presence, Hopper, after some initial and tentative efforts, rejected the art of portraiture, with two exceptions: the rare evocations of his wife, Jo, who never stopped posing for him, but in very different roles, and the *Self-Portrait*, where, hat on head, he casts on himself a slightly understanding, amused, bored, and, above all, sceptical glance, as if just having caught a glimpse of his reflection in the hall mirror. It is not a *being* in its loneliness that attracts him; it is the *idea* of loneliness. If in the street or through a lighted window he is attracted to some figure, he would not think of approaching it, nor of using his usual model to bring it closer to him through further studies. On the contrary, he draws in a manner to preserve its distance—framing the scene as he, a stranger, sees it and not as these beings live it. The system of signs by which the classical painter used to explain the action he was representing at the risk of turning the scene into his personal possession—this narrative, in other words, that Degas sought to transgress—is not in any way rejected by Hopper in these paintings. He even makes it the bitter proof of his own isolation. The network of signs is simply given to us, without those codes that would explain its meaning and reveal its value in an effort to persuade us that they hold the key to its interpretation.

It is, therefore, utterly useless to ask who these beings are that Hopper puts into different scenes, or what transpires between them, or what will become of them: Rather, we must experience with him the feeling that nobody can understand anybody else; and we must realize that, if he has favored one particular situation over another, it is only because he finds in the experiences of his protagonists the same loneliness and abandonment that he himself feels, as well as a longing and a sudden rapture of the soul which have tormented him as well. Illustrative of what, at the limits of the soul and of the world's silence, he watches for, is the young woman of *A Room in New York* (1932) who, with her husband sitting nearby intently reading his newspaper, has placed, or is about to place, a finger, nothing but a finger, on the keyboard of a piano in order to hear the vibrations of a note—a beautiful metaphor for the great potential missing from her life. But often there is hope, in addition to perplexity and sadness, as in the young girl in *Second Story Sunlight* (1960), who turns away from the quietude of a family morning because of some unknown noise, or lack of noise, beneath the balcony where she is sunning herself.

In fact, all the paintings of Hopper's second period—those works in which he has broken with the sky, with color, with the instant of his presence in the world, and now slowly pursues a study of modern life in his studio—focus either on the shudder felt by a personage suddenly estranged from his usual place of dwelling and his habitual interests or on the torpor in which this shudder might occur. These canvases have this shudder as their sole preoccupation, which erases all meanings in them, so greatly does it deny the possible meaning of signs without revealing a thing about its own motivations and values. Often, the paintings contain symbolic clues—the finger placed on the piano, for example—but it is only to draw our attention to this vanishing-point through which other meanings disappear; and this is why these paintings give the impression of silence: We have suddenly stepped back from life and from ourselves; we perceive everything as if through a thick glass. In short, we should not see in these works an American sociology, or a vaguely Freudian psychology, and especially not the reveries of a voyeur. There is no longer any intimacy to be violated when one spies on a being who is already alienated from himself; and if in his analysis of what is fugitive, nearly unconscious, and beyond

words, this painter observes women primarily, it is because a woman is less taken in than a man by the new society which Hopper observes, is less willing to prefer the quotations of the stock market to the harmonies of a sound or to the spectacle of a changing sky.

It follows—and this seems to be the main point—that this painting of existential situations as lived in society, most often in the city, and as discovered by the artist probing the stubborn and elusive recesses of the self during the long meditations of his New York winters—this unemotional painting, if such a thing exists—is not finally so different in its concerns and its values from *Squam Light* and other early landscapes. Like them, it expresses the primacy of an absolute of the instant, of a unity of life, over actions that fragment them, except that now this absolute is thought of as inaccessible, awakening only in moments of anguish or of blurred dream, and thus different from *Squam Light*, in which the painter had moved forth to meet it. Hopper's work is always an experience of Being. *A Room in New York* most profoundly mourns the life force for which *Squam Light* had been the hope.

V

Are we to believe that such mourning has stifled all hope?

In truth, in the twenties and thirties Hopper painted fewer and fewer works outdoors; or in the studio after days spent along roads or coasts. From now on, to the contrary, there are more scenes of suspended action, perceived without interpretation, which we could call *storyscapes*, in opposition to *landscapes*, but somewhat nearer to the contemporary *cityscapes*, of which *Early Sunday Morning* is an example. In these latest evocations of city architecture, Hopper identifies once again with buildings that are *there*, as if waiting, in the light—*Skyline, Near Washington Square* of 1925, for example—but, from now on, he does so only in order to acknowledge the universality of abandonment. Occasionally he is attracted by store signs, fragments of which he uses in some of his *storyscapes*, because these chance words express the meaninglessness and the absurdity of all lives.

But, nevertheless, *The Lighthouse at Two Lights* of 1929, one of his masterpieces, and the wonderful oils of 1930—*South Truro Church, Corn Hill, Hills South Truro*, and others—followed by *Sun on Pros-*

pect Street (1934), *Vermont Sugar House* (1938), or even *California Hills* (1957), all bear witness to Hopper's deep interest in continuing to work outdoors in the open air, while the very scenes of his theater—those paintings apparently dedicated to the simple awareness of the Impossible—have a structure, beneath the economy of the action, which opens once again a dimension of hope that seemed to have been forgotten.

This structure is what unites the actual scene and what, at its limits, remains of the world; that is to say, the sun of summer days, the light, which is often at the heart of the scene itself, but only as one of its inner signifiers. In *Summertime* of 1943, a young girl, carefully dressed, waits at the entrance of a house. Her shadow, falling on the steps of the stoop, is so massive and intense and so forcefully grabs one's attention—as does also the shadow of the column to the right—that it enters into the very idea of the work: One sees it almost moving. It is the blind time of stars, asserting itself against human intentions, revealing their percariousness, their futility perhaps; and as a result the body visible beneath the thin dress is itself nothing more than another aspect of cosmic matter, a pale projection of the world's night. It no longer arouses desire but a feeling of solidarity, of compassion, at the heart of the nonmeaning of all things.

But the young girl of *Summertime* is also a being who turns toward the light: who might even have allowed herself to be distracted a moment from her waiting and her thoughts by some change in the sky, as the gust of wind, which has raised the curtains in the open window, may indicate. And how many other Hoppers are played out, thus, on thresholds or in front of windows through which light comes like, yes, a signifier, but one that transcends all the others, and will awaken, within the network of social stereotypes, a person who responds to its absolute because he now understands the meaninglessness of his present condition and the extent of his solitude. In fact, the light is the most significant factor, a sign, in almost all of these truly metaphysical paintings: from the dressmaker of 1921 or *Room in Brooklyn* of 1932 to the canvases of the last period, such as *High Noon* (1949), *Cape Cod Morning* (1950), or *A Woman in the Sun* (1961). What is remarkable is that at the beginning the protagonist seemed indifferent to the ray of light coming from the sky, but then the connection is established, and will eventually become essential in a few great works. At the center of his reflections on solitude and on the awareness we derive from it,

Hopper places the brilliance of sunlight as the element that speaks to this anxiety, after having perhaps created it, and then may possibly restore hope.

In short, these paintings are *Annunciations*, without theology or promises, but with a vestige of hope. This aspect of his work has considerable meaning for Hopper's own relationship to himself, because the nostalgia of his personages is obviously his own and points to his continuously seeking, heliotropically as it were, to reestablish, as in *Squam Light*, a contact with light that would be that of presence to presence. Hopper's most pessimistic paintings, those most convinced that no transmutation could ever possibly take place, never come down to the mere *use* of light, that would fix the particulars of the drama in some enamel of cool and warm colors. Rather, it is the *attestation* of light, the affirmation that a principle endures which transcends ordinary reasons and feelings: so that certain paintings, like *Pennsylvania Coal Town* (1947) or *Chair Car* (1965), one of the last canvases, are less enamel [*émail*] than stained glass [*vitrail*], where the human event, as insufficient as it may still seem, is actually pierced by light.

Put another way, the painter of *Chair Car* has not forgotten that, with his battered felt hat over his eyes, he liked to set out to meet the world's light. The glance—which he used to cast in the direction of the hall mirror, smiling faintly when he unexpectedly caught a glimpse of those stubborn eyes, which were set on much more than the mere affirmation of things—has not yet been bereft of the hope he had placed in his watercolors. And the raison d'être of his paintings of silence and loneliness, from *Girl at Sewing Machine* on, is less the enumeration of the various social forms of an essential abandonment than a seeking that goes deeper, and may even yield a discovery.

## VI

*Morning Sun* of 1952 is certainly typical of his last paintings. A woman is seated on a bed in an obviously small room—a true nun's cell—in front of a large window completely open to the rising sun. The woman has grown old; her meditation on age, we feel, is part of the somewhat sad realization that clouds her eyes and tightens her lips, for the soul does not understand why it should depend on the body. One remembers, if acquainted with Hopper's work, that the reality of the body has always been his problem: It is matter, which the light of the sky, of the sea, of the wind does not penetrate; it is enigma; it is the abyss of an unconscious into which color does not descend except in reddish glows and dark shadows. This carnal and mortal body can be said to lie at the center of Hopper's thought even when he seems to paint only gazes, suspended motions, silences, and reveries, since, as we have seen in his preliminary drawings, he effaces from the model all signs that might give her an individuality. She is reduced for an instant, at least, to a node, a stump, a mere physical presence: a sexual reality, where erotic yearnings furtively coalesce. In fact, it is through the idea's penetration of the body that the drama revealed by the work reaches a maximum of tension in a painter whose relationship to the other has always vacillated between ordinary desire and the dream of perfect virtue.

Drawings do exist for *Morning Sun*; and one of them reveals that the placement of the body has been determined by Hopper's obsession with light. This study, in which we once more recognize Edward's wife, Jo, is covered with handwritten directions, nearly two dozen of them, each linked by small lines or arrows to various parts of the body and each specifying the relation of the flesh or the limbs to the brightness of the morning light. The notations go from "light against wall shadow" for an arm to "reflected light" for the back of the arm, or from "dark against wall" for the back of the neck to "cool reflections from sheet" for the upper part of the bare thigh. Nuances, half-tones, contrasts are all perceived and recorded. Not forgotten is the dark shadow that the body casts on the bed. What does all this mean? Above all, it indicates the fascination with the endless metamorphosis of light into value, of value into color, and, most important of all, of those points where light unfurls in contact with the body, seems to influence it, tries to penetrate it by circumventing or almost tricking it, yet without ever succeeding in overcoming its resistance. This body, half-clad in a light colored garment, is eroded, not transfigured, by the sun. Through crossed hands, it seems to refuse itself to the sun. Is it possible that, while animal life—a bird splashing in the fountain, a lamb jumping over the grass—is illuminated through simple gestures to the very depths of its emptiness, the human body, for some reason, is a self-enclosed world, full of night? Certainly, Hopper would not have dwelled so much on the study of the light falling on the model if it were not to verify both its total immanence and its transcendence. It is not this dress in the light that is going to persuade him of the fullness

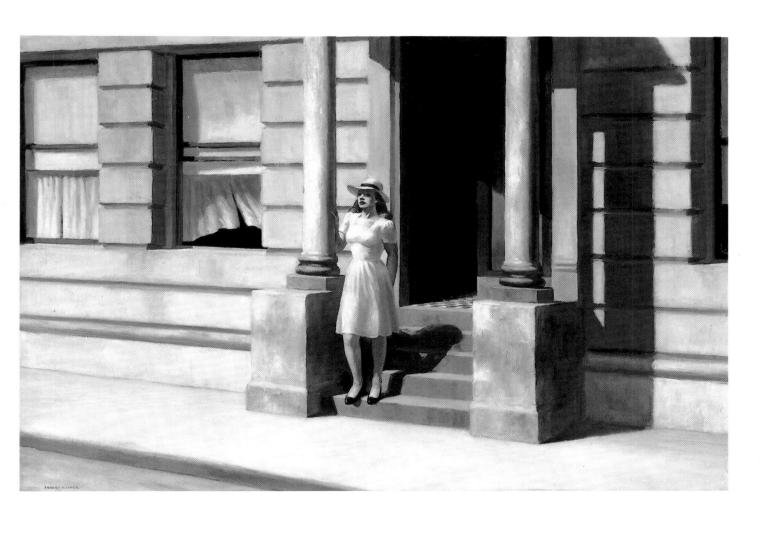

**Summertime**
1943
oil on canvas
74 × 111.8 cm.

of a lived moment. Rather, he sees its color as empty and as barren as the surface of a dead star.

But now that we are aware of this drawing, which is a spectral analysis of sorts of our presence in the world, we can see that in the painting, *Morning Sun*, work of equal subtlety has been done to the bedroom wall, except that now it suggests a completely different experience, one of exaltation, of a freeing of the soul. The drawing had already placed the woman in a neutral field which was brightened by her cast shadow, giving the impression of a sunlit beach and diminishing the importance of the value-notations—for nuance means little to someone who remembers a gleaming sea or puddles on the sand. With the painting, one must now abandon this dream, but only in order to discover a sign, which prolongs this decentering effect and recaptures its promise. On the wall behind the bed is deployed the wide, bright rectangle of the sun, which so freely enters the room. Nothing clouds its light, because the wall is bare, as the entire room seems to be. And one cannot help believing—this is the attraction of the painting—that Hopper wanted this bareness in order to yield all possible space, as in the nun's or the monk's cell, to an advent, a luminous coming, which remains for him the true object of attention, whatever his fascination for the enigmatic being of the body might be.

It is time to note that the bareness of the walls and the absence of furniture and objects are one of the characteristics of Hopper's interiors, which become more and more marked in the years after the war. This bareness is not essential to the events transpiring here—why should it be necessary for the office in *Conference at Night* (1949) or the train compartment in *Chair Car* to be without calendars or posters?—but is a pseudo-narrative decision which allows wide patches of empty light to extend over the canvas. Reality itself is obliterated in this abyss, at least the reality of existence, which endures only through the signs it projects around itself.

Perhaps this is exactly what is taking place or at least is beginning to take place. In the very scenes where Hopper seems merely to assert the inability of human beings to talk to one another, to overcome loneliness, or in which he simply expresses the emotion that light awakens in them, he is far more present, for he has already started the process through which, watching the sun move on a wall, letting it boundlessly spread its silent folds, one is able to lose oneself in the silence, become the emptiness of inanimate things, and throw off the contradictions one has endured. If humans remain sealed within themselves, existence dependent on the body and on the world, does this mean that the mind cannot venture forth? And as a painter of the intensity that blazes between light and matter—is he not better suited than anyone else to dedicate himself to this quest? Already, in *Rooms by the Sea* of 1951, Hopper paints hardly anything but a bare wall near a door that, opening wide onto a nearby shore, reveals nothing but the sky and a very blue sea. Are we simply in a hallway opening onto a room, through whose door one sees a sofa and a chest of drawers? But this is the furniture of hotels, designed for stays that leave no trace. And farther along this way, in 1963, near the very end of Hopper's life, *Sun in an Empty Room* embraces the same great light in what is undeniably, this time, a bedroom, but one completely devoid of furniture, as if movers had carted away the things that had once made life possible. There is no doubt that Hopper wished to go beyond the reality of this world in the very act by which he gave it form. Understanding that he could not establish a positive relationship with Being, with the Absolute, mediated, that is, by things, feelings, actions—and the presence of other beings—he seeks the negative way, the one that creates a void in consciousness, so peace may enter and dwell therein.

"I am after ME,"[10] Hopper said of *Sun in an Empty Room*. In this bedroom where the sun moves, it is with spiritual growth that he is concerned, as is true in quite a few other scenes where the observation of beings, often reflections of himself, is the recollection that will be his point of departure. In short, this obviously metaphysical painting was also a mystical experience. During the last years of his life they became particularly intense and reached an almost pure state. For it is true that the last painting, *The Two Comedians*, represents Hopper and his wife, Jo, as two actors of the *commedia dell'arte* bidding farewell to their public; it suggests the painter's retrospective and sorrowful glance over his entire life, and the frustrations and disappointments in his personal odyssey. But it appears that the theater is as empty as the stage and that the light illuminating the man and woman is the dawning light of a distant day. Hopper had just painted *Chair Car* where the immobility of the sun through the windows negates the speed of the train moving silently toward an unknown destination. In fact, the painter's true testament is the extraordinary *Road and Trees* of 1962. Here, across the road, running from left to right—symbol of the time that, from birth to death, seems to go nowhere—is a small forest,

so dark it appears impenetrable, but at its edge, on the side and at the top of two trees, the golden light of a rising sun glows. "There is a sort of elation about sunlight," Hopper remarked.[11] It is this exaltation, this happiness, looking at a roof or a treetop bathed in light, which became his resource, his constant thought, his testimony, from the moment he discovered, in Paris, how light can enhance color.

## VII

This discovery affords a better appreciation of Hopper's place in contemporary painting and a better understanding of a singular aspect of his stay in Europe. It is surprising to learn that this young man in the Paris of 1908 was not interested in the remarkable happenings of the avant-garde, of which he was certainly aware, since he knew about Gertrude Stein's activities. But what need had he of the new accomplishments of Cubism and of an art that was beginning to identify with the artist's interpretations, with abstract structures without concern for what they stand for; while, on the contrary, his concern was indeed with the subjects—for instance, those roofs lit up in the distance, those trees, that world in the light, which no system of signs in the history of religion or art had ever been able to express without deep spiritual elaboration? Rather, it was more important for him to feel that the possession of the world and of the light offered by Impressionists or Fauvists was vital in a society that would not long maintain such gardens intersected by brilliant waters as found at Giverny, or such villages that were relatively unsophisticated at the turn of the century.

Vallotton, the European painter who has the greatest affinities with Hopper, came, as did Hopper, from a bastion of the Reform movement, the Calvinist canton of Vaud in Switzerland. Mondrian's *The Red Cloud*, which is the work of 1908 or 1909 closest to Hopper's landscapes of the time, is also the product of a Calvinist tradition, one that inspires questioning of earthly values because of an all too proximate God—whether perceived to be living or dead. The great or minor gifts of Impressionism have a quality of reality and a happiness regarding life that seem natural, especially beneath a certain kind of sky; but one should not forget the challenge they were to some people in the West, which for so many centuries has been obsessed by a religion so ambivalent about earthly things. What is given to certain minds, others must verify, convince themselves of: a need that will produce a

metaphysical painting, even if it seems to admit to the experience of the senses. Indeed, it is this metaphysical preoccupation that will make painting more capable of reflecting the value and the miraculous quality of a hard-won presence in the world, and more anxious to preserve it, even if this means confining it to only a few simple possessions. Hopper understood in Paris that this critique of "realisms," often so superficial, this preoccupation with the significance of signs, remained, at the beginning of this century, the essential task of painting. It is possible that for this we shall, someday, be grateful to him, when new times make their way through the damages left behind by our own.

One final remark. In this very preoccupation Hopper discovered artists who in more informed periods had experienced, better than we, the relation of the symbol to a presence, though the presence was then divine; for this reason, he was drawn to Dutch art. Thus, it is reasonable to link Hopper to Vermeer of Delft. For there is the same sense of interrupted narration in Vermeer—this geographer has just noticed something we do not see, this young girl has just received a letter about which we will learn nothing—and in both painters there is the same rapid dissipation of our curiosity before these fleeting mysteries. But in the "master of olden times"—as Fromentin would have said—it is because a reality of more evident richness than any event of daily life penetrates the illustration of the narrative, stretching its seams, elevating its meaning. Vermeer paints everything so precisely, so fully, so interconnected with other things and other beings—it is his very own kind of lace, as seen in the painting in the Louvre, which Hopper must have seen often. He paints a scene so peaceful, to use the word in its deepest sense, that this suspension of human values does not have to leave the level of things to resolve itself in God; whereas Hopper, after his few confident months in Paris, will only be able to find the absolute in pure light, in its silence beyond things, and will have to come to see his own existence as a foreign body that must first be effaced in order to let light enter. Of course, it may seem absurd to compare the believer and the atheist, the one who knows and the one who seeks. But presence and absence are the same unique mystery, through which color flourishes, in which form breathes. And the painter who lives in exile, but knows it and suffers from it, is of greater value than the symbol that has no meaning, on an earth that is coming apart.

*Translated by Richard Stamelman*

1. Hopper spent most of his boyhood and adolescence in Nyack, New York, a thriving port town along the Hudson River, where he was born in 1882. When he was about fifteen he built a catboat from materials and tools given to him by his father, who wanted his son to spend more time outdoors away from the books he was constantly reading. (Gail Levin, *Edward Hopper: The Art and the Artist* [New York: W. W. Norton, in association with the Whitney Museum of American Art, 1980], p. 16.) [*Translator's note*].

2. Quoted by Lloyd Goodrich in his *Edward Hopper* (New York: Harry N. Abrams, 1971), p. 19. [*Translator's note*].

3. Also named "La lune blanche," the poem is part of a series of nuptial poems (epithalamia) entitled *La Bonne Chanson* written by Verlaine in 1870 to his fiancée.

Hopper married Josephine Nivison in July 1924. [*Translator's note*].

4. Quoted in Goodrich, *Edward Hopper*, p. 99. [*Translator's note*].

5. Bergotte, the writer, in Proust's *The Remembrance of Things Past* leaves his sick bed to go see Vermeer's *The View of Delft*, on loan from a museum in The Hague. While looking at the masterpiece, in particular its sublime representation of a patch of sundrenched light falling on a wall, he suddenly becomes ill, sinks down on a settee, as the words "little patch of yellow wall, with a sloping roof, little patch of yellow wall" echo in his mind, and dies. (*The Remembrance of Things Past*, III: *The Captive, The Fugitive, Time Regained*, trans. C. K. Scott Moncrieff, Terence Kilmartin, Andreas Mayor [New York: Random House, 1981], p. 185.) [*Translator's note*].

6. Quoted in Goodrich, *Edward Hopper*, p. 31. [*Translator's note*].

7. Quoted in Levin, *Edward Hopper: The Art and the Artist*, p. 19. [*Translator's note*].

8. Quoted in Gail Levin, *Edward Hopper* (New York: Crown Publishers, 1984), p. 39. [*Translator's note*].

9. Quoted in Goodrich, *Edward Hopper*, p. 99. [*Translator's note*].

10. Quoted in English in the original. See Levin, *Edward Hopper: The Art and the Artist*, p. 9. [*Translator's note*].

11. Quoted in English in the original. See Levin, *Edward Hopper: The Art and the Artist*, p. 64. [*Translator's note*].

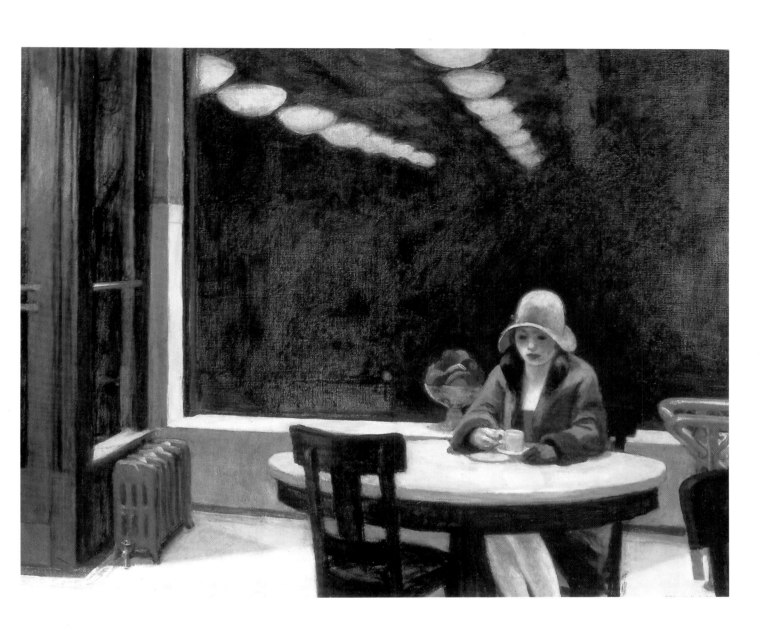

**Automat**
1927
oil on canvas
71.5 × 91.5 cm.

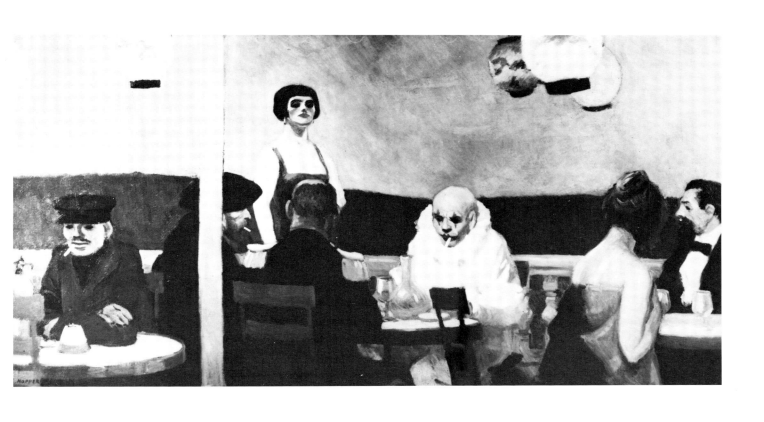

**Soir Bleu**
1914
oil on canvas
91.5 × 183 cm.

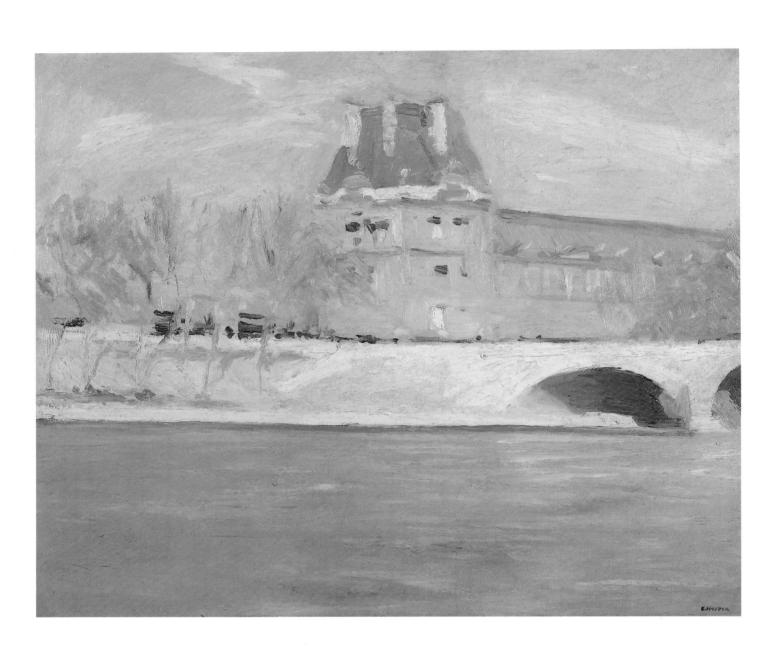

**Après midi de juin***

1907

oil on canvas

59.7 × 72.4 cm.

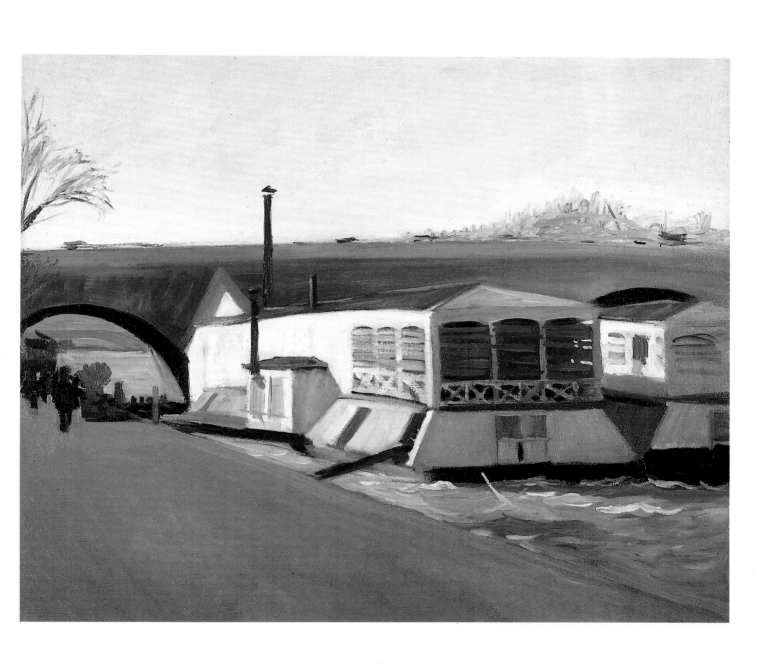

**Les Lavoirs à Pont Royal***
1907
oil on canvas
59.06 × 72.39 cm.

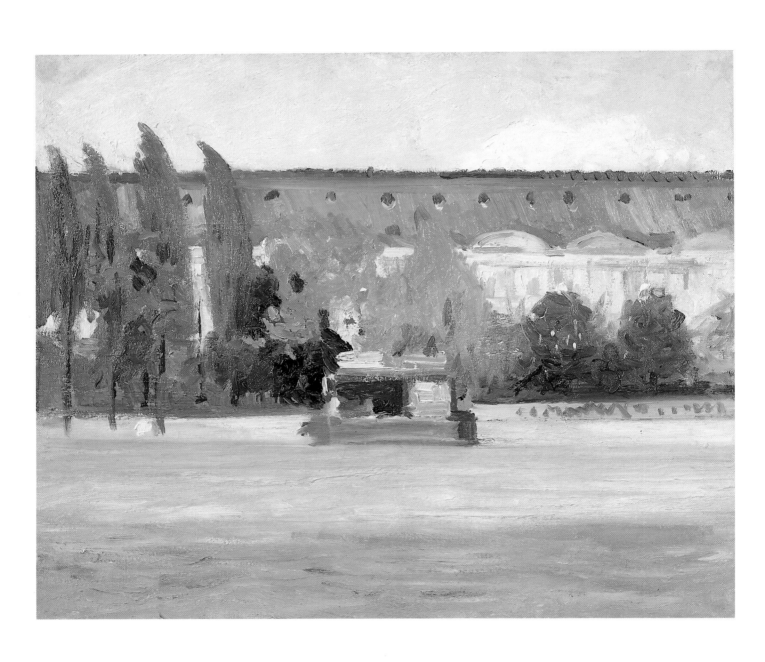

**Louvre and Boat Landing***

1907

oil on canvas

58.4 × 71.7 cm.

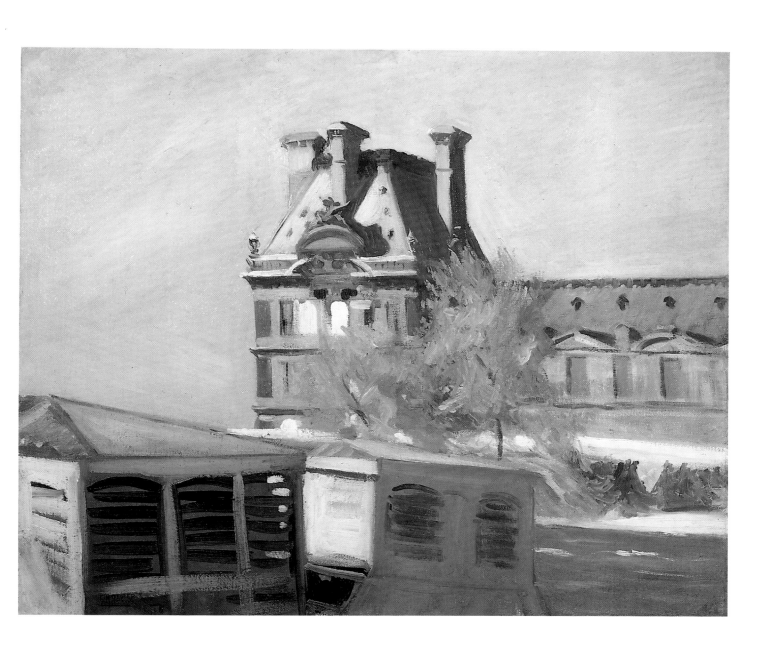

Le Pavillon de Flore*
1909
oil on canvas
59.69 × 72.39 cm.

The time Hopper spent in Paris was decisive in his development as an artist. Encouraged by Robert Henri, his mentor at the New York School of Art, to study French painting (Manet, Daumier, Millet), Hopper long retained the memory of his three trips to Paris (one from October 1906 to August 1907; another between March and July 1909; then several weeks in 1910, which were interrupted by a trip to Spain). It was with his impressions of Paris that he first sought recognition, so much so that his later success as a chronicler of the American Scene may seem either a nostalgic return to his homeland or a painful departure from the Francophilia that his first exhibitions failed to arouse in his countrymen. Painted after his return to New York, in 1909, *Le Bistro* illustrates the pictorial contribution of the Paris experience and clarifies its impact on all Hopper's work. As in most of his mature works, we find here already a very precisely constructed synthesis and no longer the guileless treatments of civic and palatial architecture he had earlier produced along the Paris quays. Hopper abandons the Post-Impressionist brushstroke that he adopted during his first trip, when Patrick Henry Bruce introduced him to the work of Sisley, Renoir, and Pissarro, in favor of a more unified, Luminist method that recalls Marquet, whose exhibition at Druet he had visited in 1907, or Vallotton, whose paintings he had seen at the Salon d'automne. He fluently contrasts the various parts of the canvas in order to create among them a poetic and symbolic tension. On the one hand, there are the Parisian buildings (characterized by their somber verticality), the contrasting tiers of the storefront and upper façade, and the merchant's sign; they seem to yield to the morning breeze and are highlighted by the spiral motif of the two seated customers. On the other hand, there is the deliberately airy space. With its emptiness swept by pale shadows, its water flowing under the gentle arches of a bridge, and the golden bending of its four poplars, it is like a tender metaphor for the feminine universe.

Robert Hobbs has emphasized Hopper's interest in a world in flux and his fascination with the diverse responses of cities as dissimilar as Paris and New York to the conflict of culture, industrialization, and nature that characterizes the twentieth century. For Hopper, what most distinguished Paris was the quality of its light, so "different from anything I had ever known. The shadows were luminous—more reflected light. Even under the bridges there was a certain luminosity." In this attention to light and its power of spiritualization, Hopper goes beyond Steinlen's naturalistic observation of Paris and attains a global intensity of emotion in which the individuals already seem subjugated to a fate that transcends them.

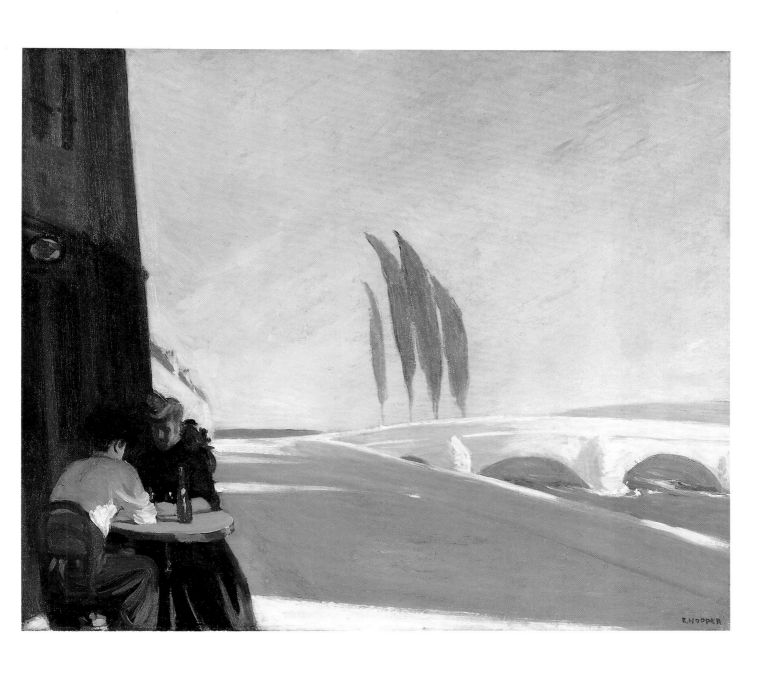

**Le Bistro** or **The Wine Shop***

1909

oil on canvas

59.37 × 72.39 cm.

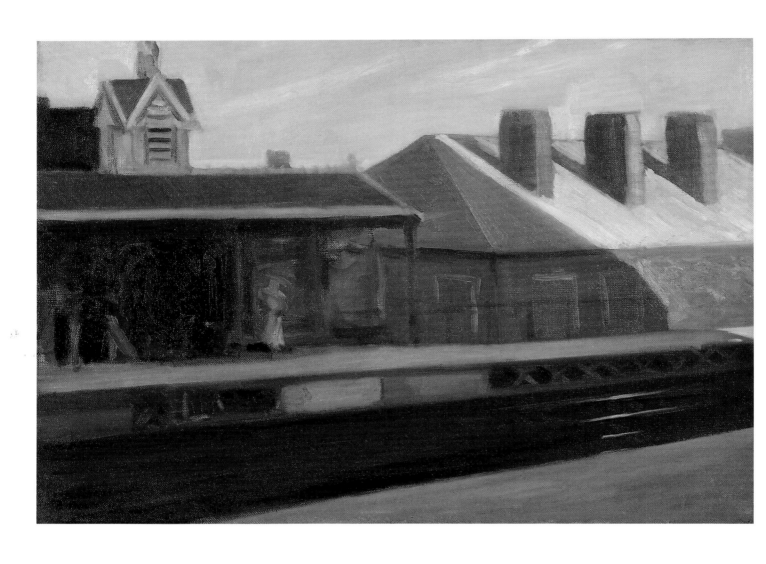

**The El Station***

1908

oil on canvas

50.8 × 73.7 cm.

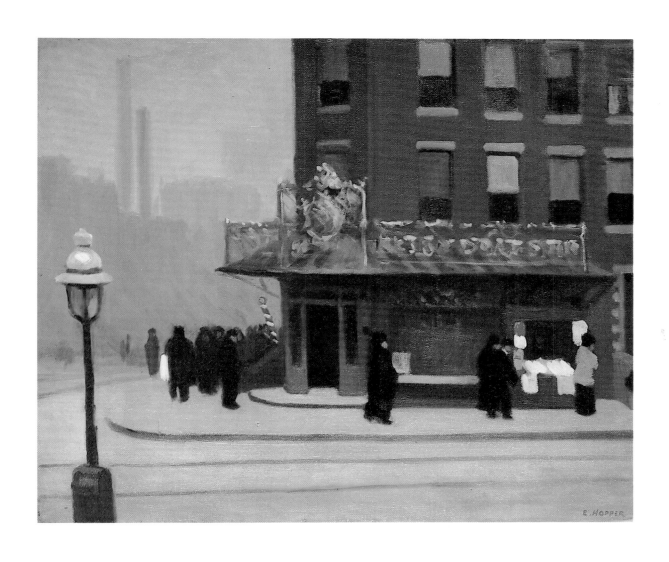

**New York Corner** or **Corner Saloon***
1913
oil on canvas
61 × 73.7 cm.

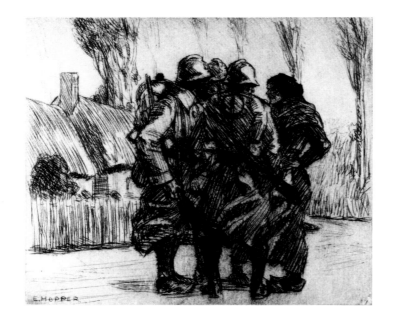

**Les Poilus***

1915–1918

etching

23.5 × 26 cm.

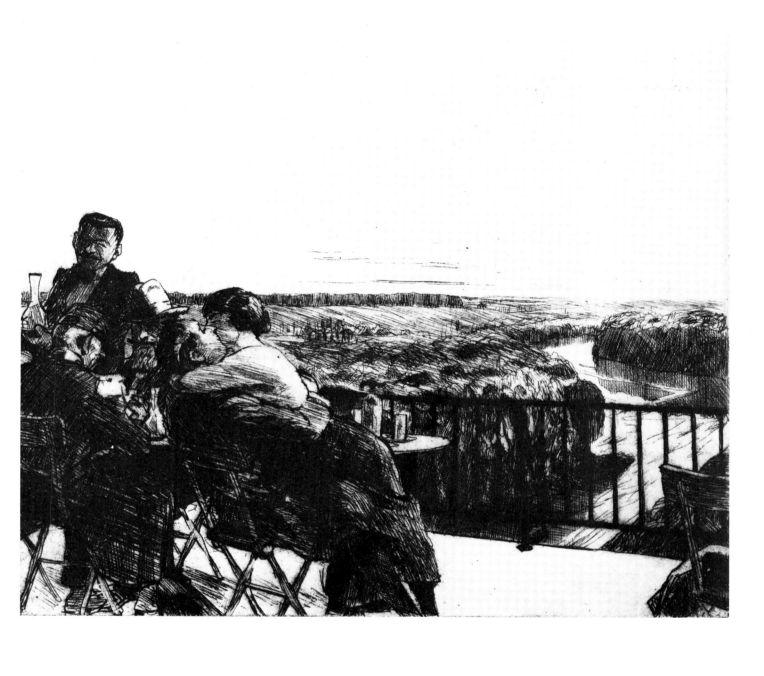

**Les Deux Pigeons\***
1920
etching
21.2 × 25 cm.

Forced to earn his living as an illustrator, a job he performed with little relish, Edward Hopper doubtless drew from this experience an increased sense of the power of representation. We know of his interest in French posters and German graphic design. They no doubt confirmed the importance of a tightly structured composition, of constructions framed by unusual perspectives that the neutral lens of a camera might otherwise reveal. Although we possess few details about his interest in photography, he was probably aware of its artistic and commercial development. In photographs of Versailles and New York taken in the 1910s by Edward Steichen, we find compositions similar to Hopper's and the same preoccupation with light, including a pronounced fondness for twilight and nighttime effects. Moreover, the commercial use of photography affirmed the objectivity of the report and, paradoxically for an art of the instantaneous, provided a feeling of timelessness. The practice of etching, particularly between 1915 and 1923, permitted Hopper to free himself both from his French themes and from the literal narration required of the illustrator. He admired the work of Rembrandt, Goya, and Méryon and was no doubt influenced by the prints of John Sloan, with whose urban themes and compassionate depiction of the middle-class's everyday universe he felt a kinship. What characterized Hopper from the outset, however, was his ability to describe, without the sentimentality of Sloan's anecdotes, the universe of solitude and expectation. This stint in the graphic arts allowed him to break with his "out-of-doors Expressionism," a style that had clearly tempted him between 1916 and 1919, as seen in his work from Monhegan Island in Maine. It also enabled him to direct his efforts towards the tension provoked by immersing a solitary human existence in space—a space torn apart. The emotional impact is furthered by the thickness of the air, the passage of time, and the symbolic nature of the environment.

The event is not described or recounted. It is perceived almost surreptitiously, at the bend in a path (*Night in the Park,* 1921), through a car window (*American Landscape,* 1920) or from an apartment during a sleepless night: *Night Shadows* is the most striking of this series, through the dynamism of its deliberately awkward, overhead composition and the clear-cut opposition of light and shadows. It stresses, like Expressionist cinema, the reverberant heaviness of a deserted street, the ambiguity of the walker's movement, which may be advance or retreat, the inexorability of human destiny (here abruptly cut short by the transverse shadow), the sexual suggestion that in Hopper's work never results in a euphoric, fruitful fusion.

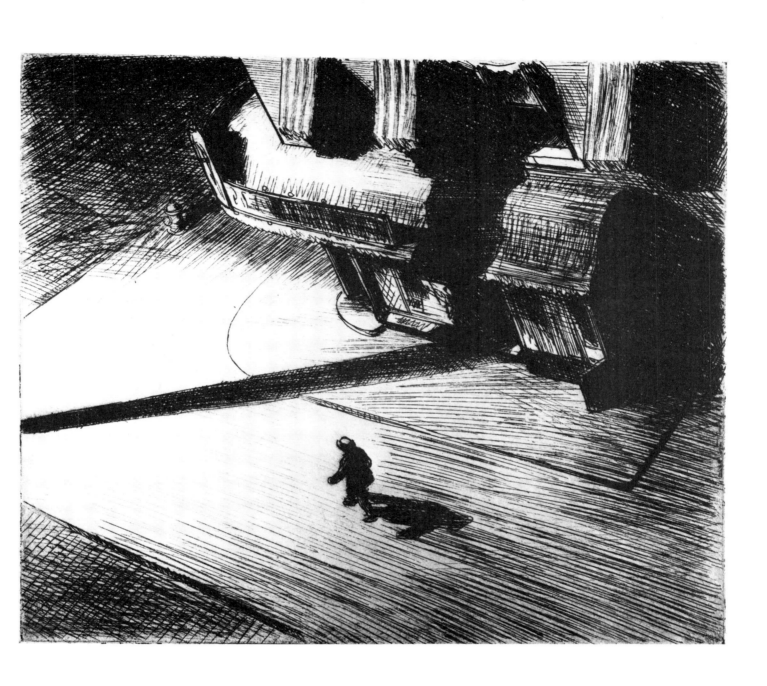

**Night Shadows***
1921
etching
33.81 × 36.2 cm.

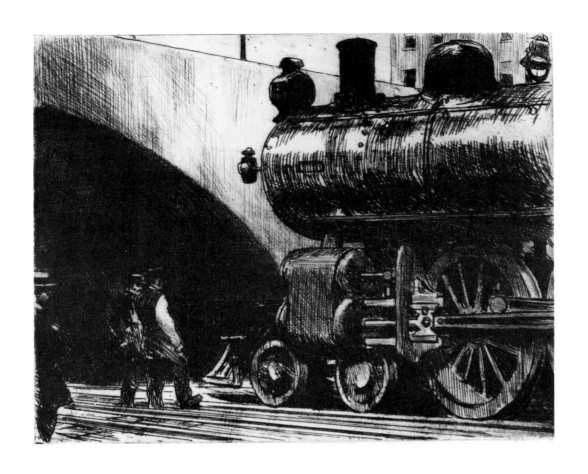

**The Locomotive***

1923

etching

34.61 × 40.96 cm.

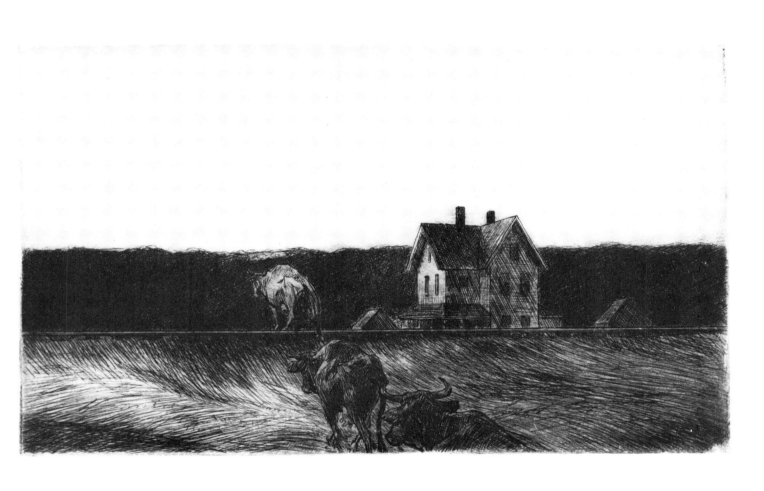

American Landscape*
1920
etching
35.08 × 46.36 cm.

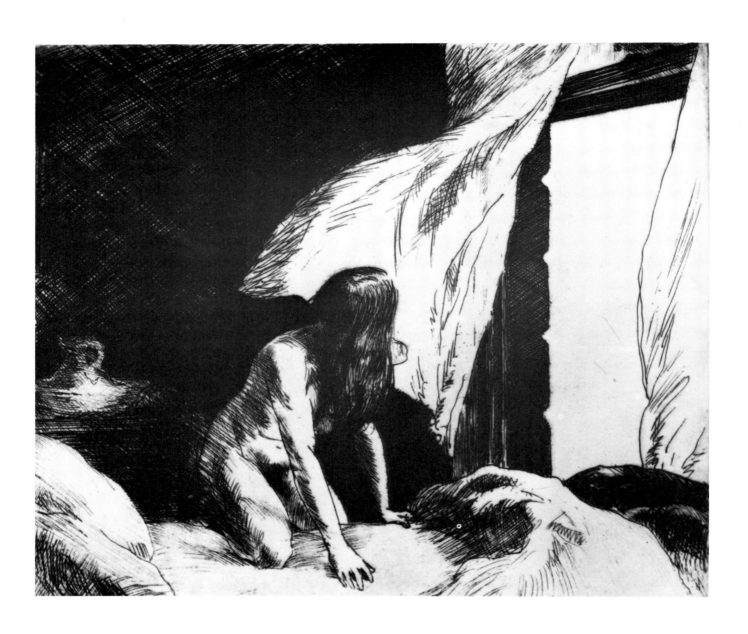

**Evening Wind***

1921

etching

17.6 × 21.1 cm.

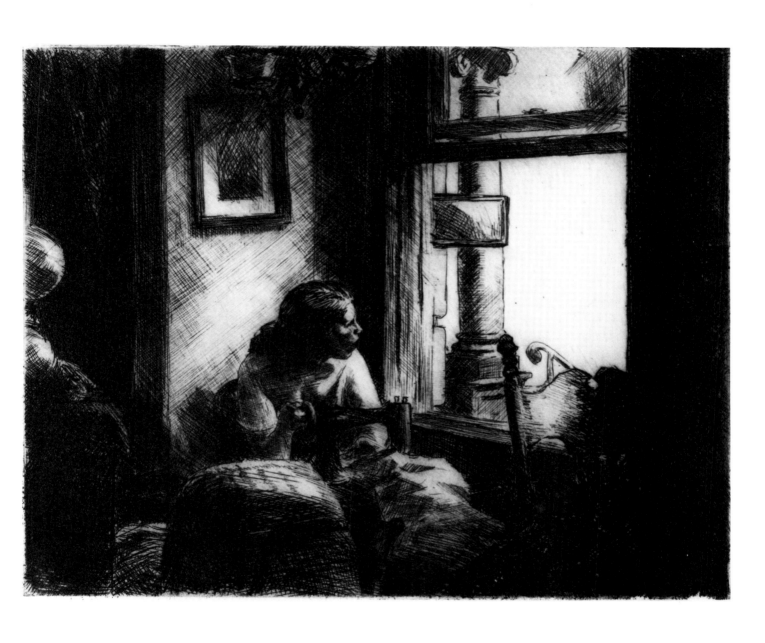

**East Side Interior***

1922

etching

34.29 × 45.72 cm.

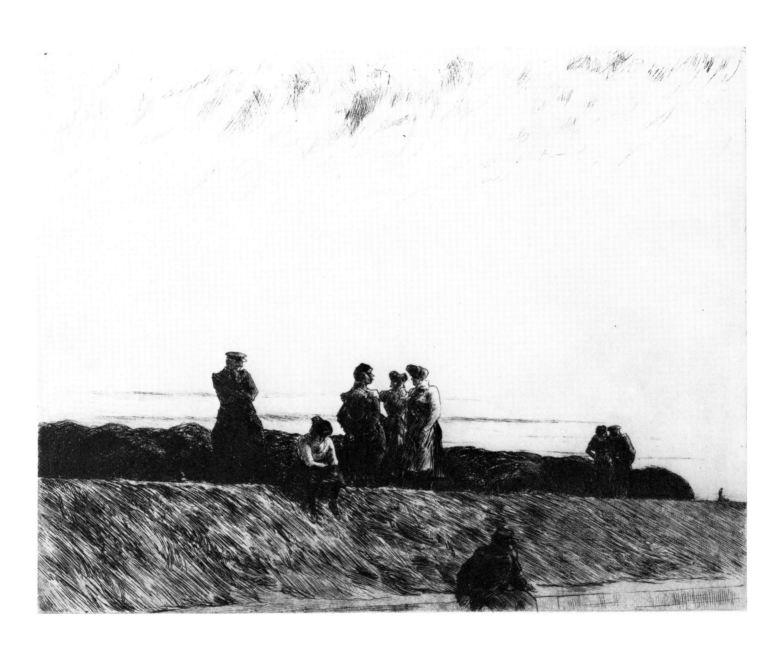

**Aux Fortifications***

1923

etching

30.1 × 37.8 cm.

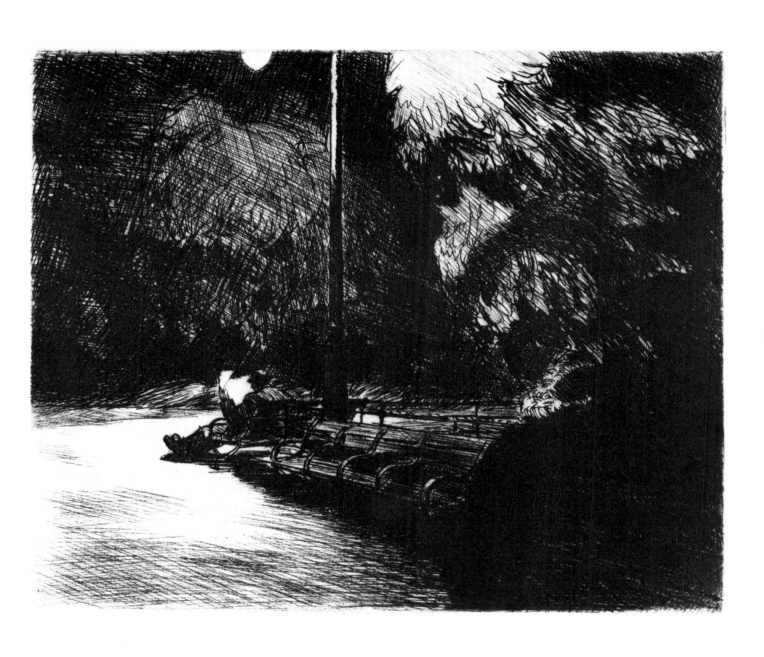

**Night in the Park***

1921

etching

34.29 × 37.78 cm.

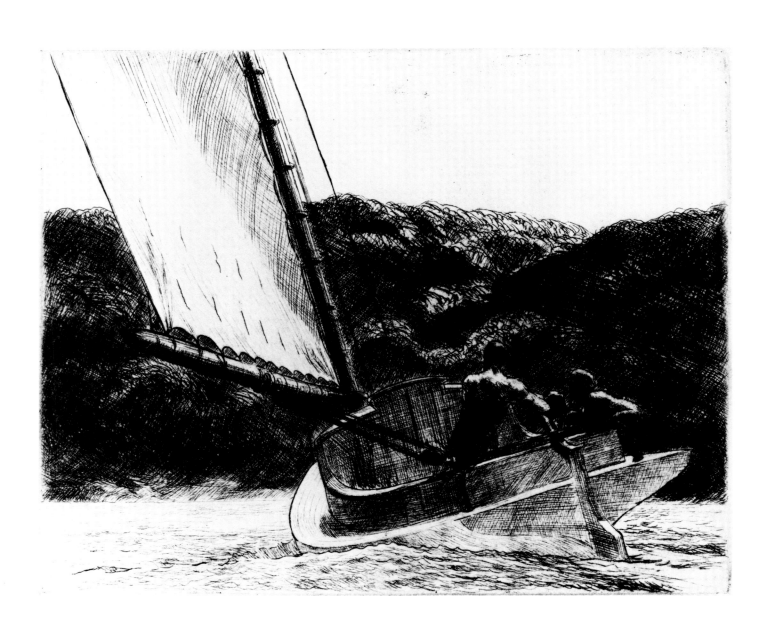

**The Cat Boat***

1922

etching

20 × 24.9 cm.

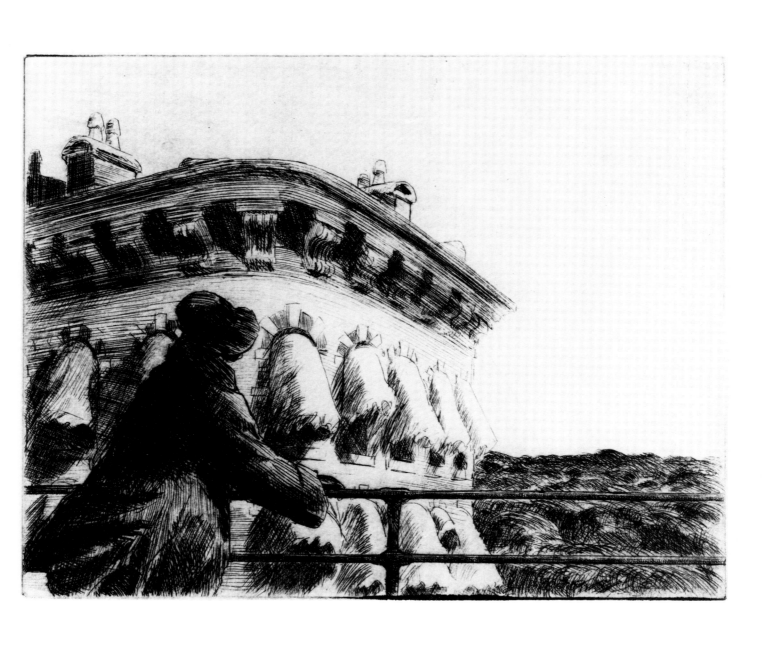

**Girl on a Bridge***

1922

etching

32.54 × 38.26 cm.

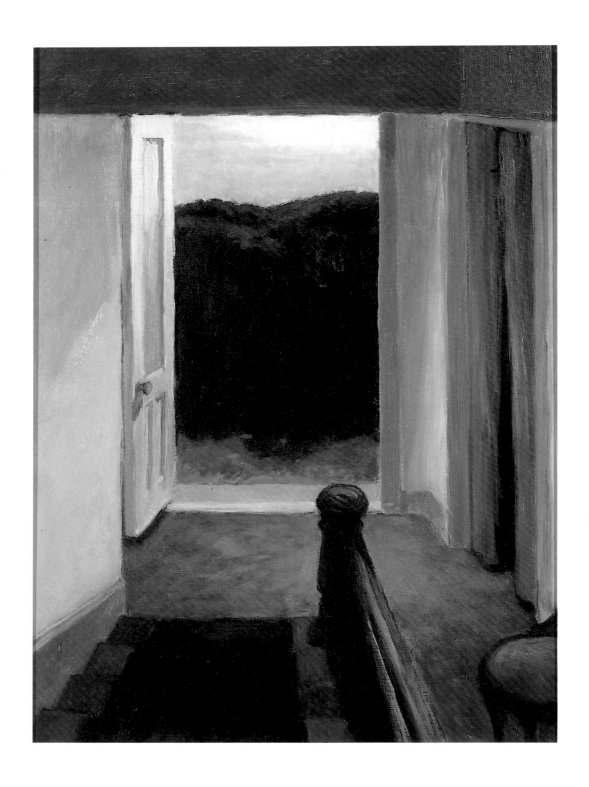

**Stairway***

1919

oil on wood

40.64 × 30.16 cm.

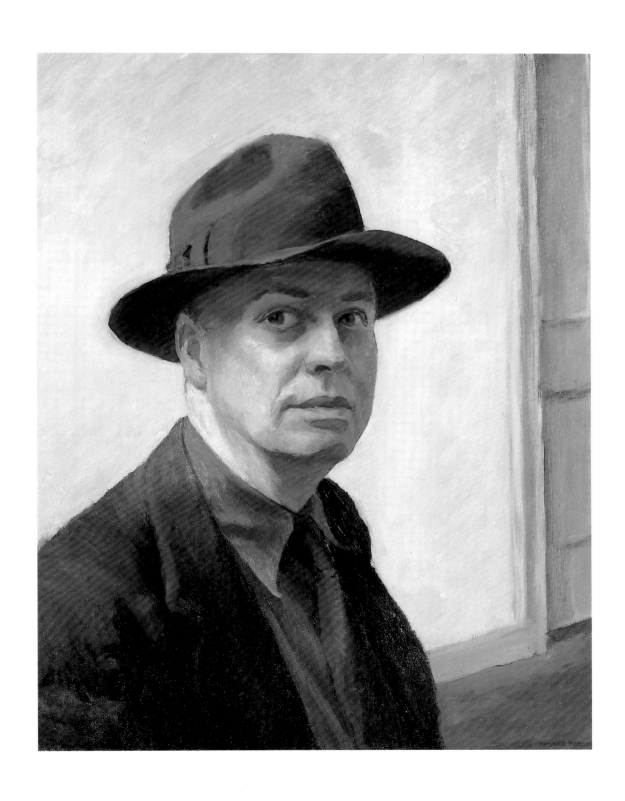

**Self-Portrait***

1925–1930

oil on canvas

63.82 × 51.44 cm.

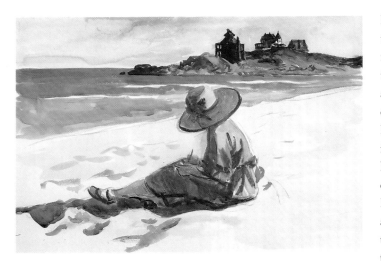

Edward Hopper's work was but one long introspection. Intrigued by the psychoanalytic theories of Freud and Jung, he volunteered that "so much of every art is an expression of the subconscious." If we encounter many self-portraits in the first years of his artistic apprenticeship and another from his prime (now at the Whitney), a few recollections of his parents, and some evocations of the private life he shared with his wife Jo, it is nevertheless surprising to note that he painted his friends and family only rarely, with the exception of Jo, who became his sole model after their marriage, posing, like an actress, as the embodiment of archetypes. Accepting no commissions for portraits, Hopper seems to have transferred all his psychological insight to architecture. The houses that he depicted constitute a veritable portrait gallery; he took an interest in their morphology and a liking to their eccentricities, the hybridization or the cultural transplantation that they revealed in an America undergoing a complete transformation between the wars. It is no doubt significant, therefore, that the first work an American public collection acquired was this watercolor (*The Mansard Roof*) purchased by the Brooklyn Museum for $100 in 1923. It is as if middle America at last recognized itself in the work that would soon come to personify it. The next year Hopper married Josephine Verstille Nivison, a fellow student from Robert Henri's studio. In encouraging him to return to watercolor, she had placed him back in the American tradition of Thomas Eakins and Winslow Homer. The work he did then in Gloucester, Massachusetts, constitutes a sort of census in which the inhabitants are clearly identified: the Adamses, the Haskells, the Hodgkins, Captain Kelly's family, . . . But this almost journalistic realism is tied to a deserted setting, the better to emphasize the signs of economic and social change. Hopper said of this watercolor, "The residential district where the old sea captains had their houses . . . interested me because of the variety of roofs and windows, the mansard roof. . . . I sat out in the street . . . it was very windy. . . . I think it's one of my good watercolors of the early period." In the summer light, this already archaic emblem of Victorian prosperity becomes an image symbolic of a feminine fantasy—impregnated by the wind, by turns sparkling and austere, gossipy and secretive. In painting them from life, Hopper collected very reliable materials with which he would later compose the conceptual portrait of an imagined America.

**Jo Sketching at the Beach***
watercolor on paper
35.24 × 50.8 cm.

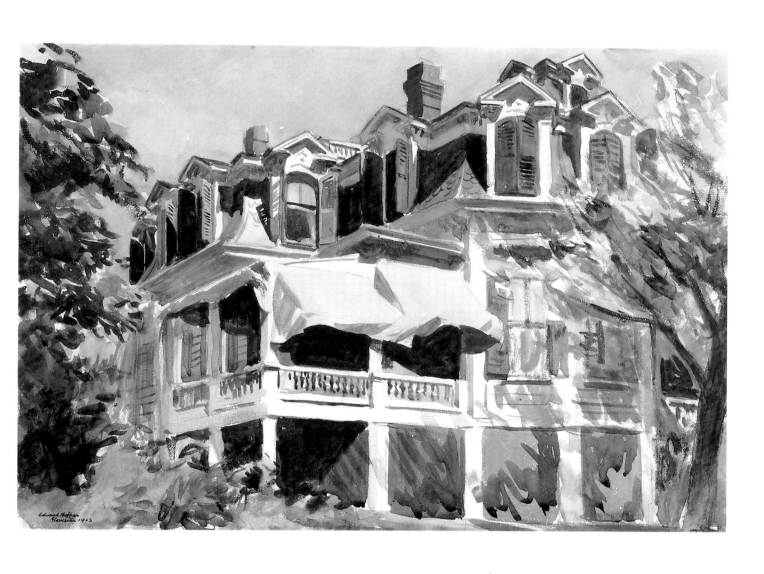

**The Mansard Roof***

1923

watercolor over pencil on paper

35.5 × 50.8 cm.

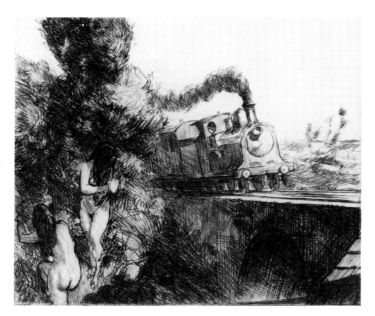

In 1925, with *House by the Railroad*, a painting of modest dimensions, Hopper created one of his most powerful, emblematic images of America. A vision. A frame from a road movie. An establishing shot from a silent film. A fleeting, indifferent glance through a car window during a long journey. Hopper himself was fond of such trips, like so many other middle-class Americans of the day, who discovered as tourists the dimensions of their continent. This house bears witness to a time that is no more; its decrepit, turn-of-the-century architecture seems to hark back to a comfortable and sedentary life, variously mocking the splendors of mother Europe. The house is an oddity that the declining light rotates in the immobile air—with its lively arrises alternating light and shadow; its peristyle, tower, and cornices; the concave apron of its mansard roof, its lifeless gemeled windows. A transplanted house whose foundation is cut off and concealed by the railroad tracks. An accident in the infinite stretch of unrolling progress. Like perforations in a film reel, the railroad ties represent a sequential horizontal scansion opposed to the verticality of the house. We know that Hopper was fascinated by the power of the railroad, which traversed the country, entering the towns and disappearing into gaping tunnels. The theme appears very forcefully as early as his first Paris trip (1906–1907), then again in 1908 (*Railroad Train*, Addison Gallery of American Art, Andover, Massachusetts). It remained constant until the early 1950s, bearing a clear sexual symbolism in watercolors such as *American Landscape* (1920), in which a procession of swollen cows crosses the horizontal line of the tracks heading for a seemingly isolated house, and especially *Train and Bathers* (1920), which combines female nudes with locomotives. In the present work, the feminine-masculine duality is emphasized by the opposition of warm and cool tones, the ardent swelling of the chimneys responding to the reddish-brown of the rails. We will find an incandescent version in *Railroad Sunset* (1928), in which an observation tower and the parallels of the track combine with the undulations of the hills. The house in *House by the Railroad* is a universal place. To Lloyd Goodrich, who asked about the location of his subjects, Hopper replied: "Nowhere or," tapping his forehead, "in there." This conceptual vision of painting merged with the illustration of a repressed and Puritan America encountering a changing world of roadside enterprises, empty highways and scraggly towns. It may or may not have had cinematic origins, but it was soon to exert a profound influence on the cinema, providing the setting for Hitchcock's *Psycho* (1960).

**Train and Bathers***
1920
etching
34.45 × 38.1 cm.

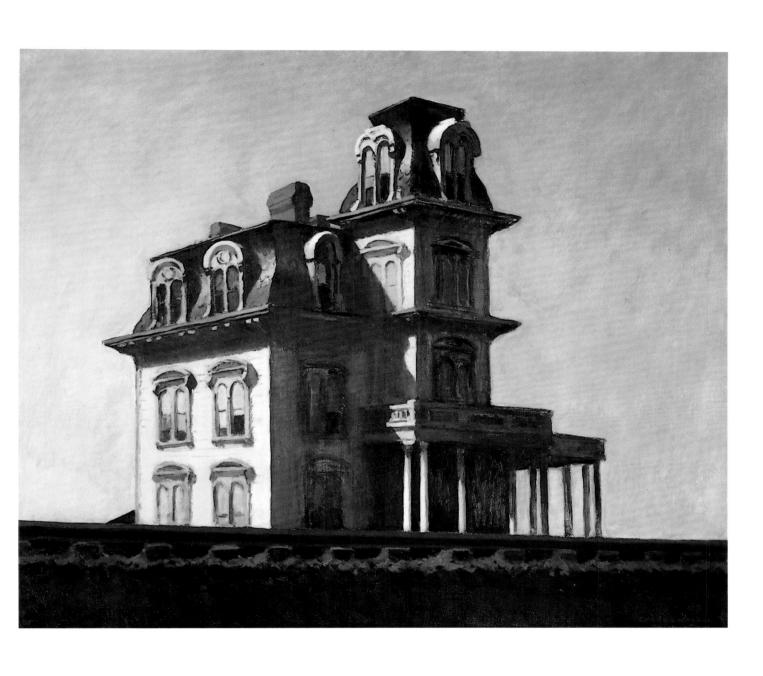

**House by the Railroad***

1925

oil on canvas

61 × 73.7 cm.

**Victorian House***

watercolor on paper

35.24 × 50.48 cm.

**Saint Michael's College, Santa Fe***
1925
watercolor on paper
35.24 × 50.64 cm.

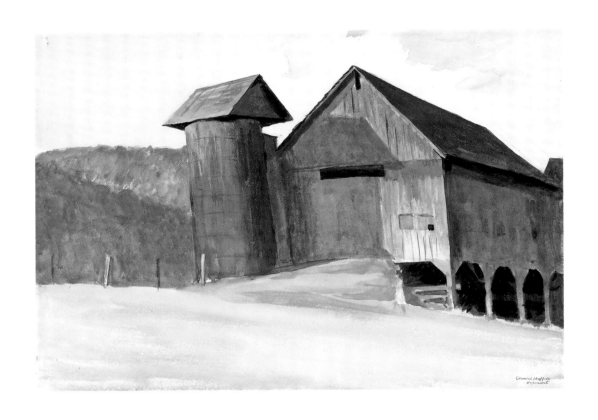

**Barn and Silo, Vermont***

1927

watercolor on paper

35.2 × 50.5 cm.

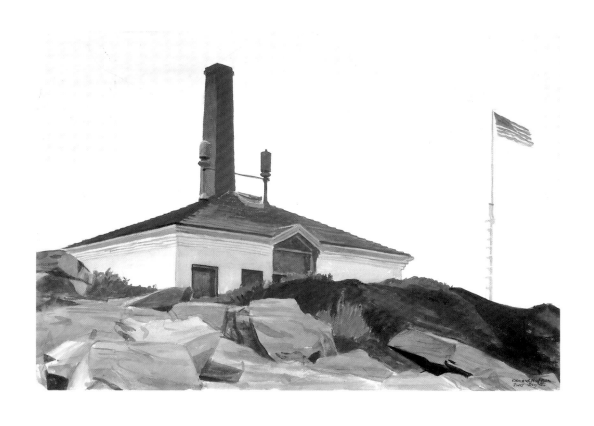

**House of the Fog Horn 1\***
1927
watercolor over pencil on paper
35.8 × 50.6 cm.

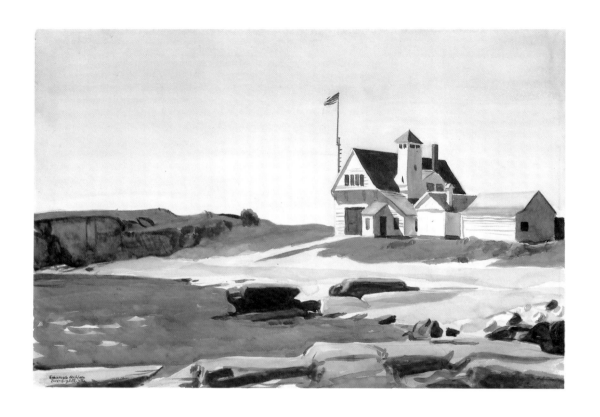

**Coast Guard Station, Two Lights, Maine***

watercolor on paper

35.2 × 50.5 cm.

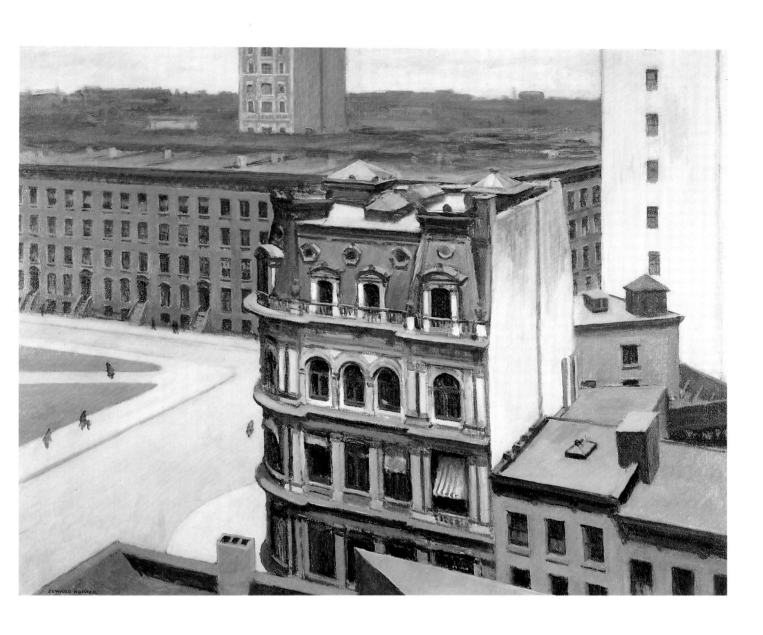

Edward Hopper deploys a constant to and fro between exterior and interior, between the limitless space that has always fascinated American artists and the shrinking world that encloses the isolated individual. *House by the Railroad* (see page 57) offers a diurnal version of this dialogue; *Night Windows* adopts the same rhythm. Several years later Hopper addressed the subject of *Office at Night* (1940; see pages 80–81): "The picture was probably first suggested by many rides on the 'L' train in New York City after dark and glimpses of office interiors that were so fleeting as to leave fresh and vivid impressions on my mind. My aim was to try to give the sense of an isolated and lonely office interior rather high in the air, with the office furniture which has a very definite meaning for me." The voyeur retains from this subliminal perception a greater emotional intensity, and Hopper transmits this sudden desire to the viewer of his painting. In *Night Windows,* the glimpse of intimacy suggested by a few significant elements (the bed, the radiator, the meadow-green carpet) focuses on the female rump and the thin curtain lifted by a summer night's breeze. The force of our desire is compounded by the confinement and inaccessibility of its object. Edward Hopper has often treated the theme of a modern Danaë prey to a luminous and ravishing wind, whose source has been identified in an etching by John Sloan, *Night Windows* (1910). We see it initially in prints, such as *Evening Wind* (1921; see page 46), then in paintings, such as *Moonlight Interior* (1921–1923); *Eleven A.M.* (1926); *Morning in the City* (1944; see page 87); *Morning Sun* (1952; see page 99); and *A Woman in the Sun* (1961), in which light replaces the wind. Unlike the steady watch maintained by the hero Alfred in Hitchcock's *Rear Window* (1954), our attention is focused on the brief moment of a plot whose few clues nourish our imagination. The point of view, from the elevated train track, allows the painter to combine (as is common in his work) the isolation of the subject, the frontality of the canvas, the dynamic turning of the building's corner, and the sequentiality of the illuminated openings and their reflections. The instantaneity of the action is dissolved, as the progression of the dark façade introduces an element of time.

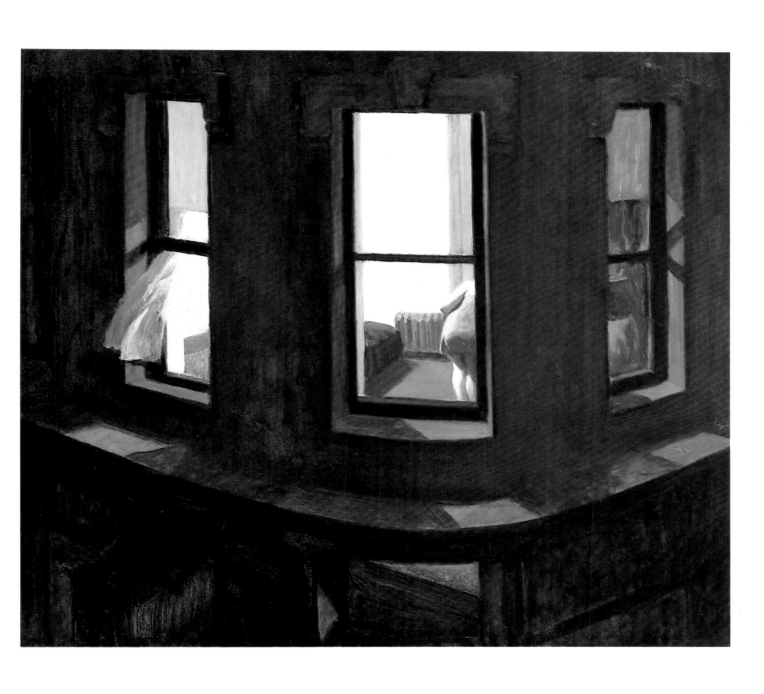

**Night Windows***

1928

oil on canvas

73.7 × 86.4 cm.

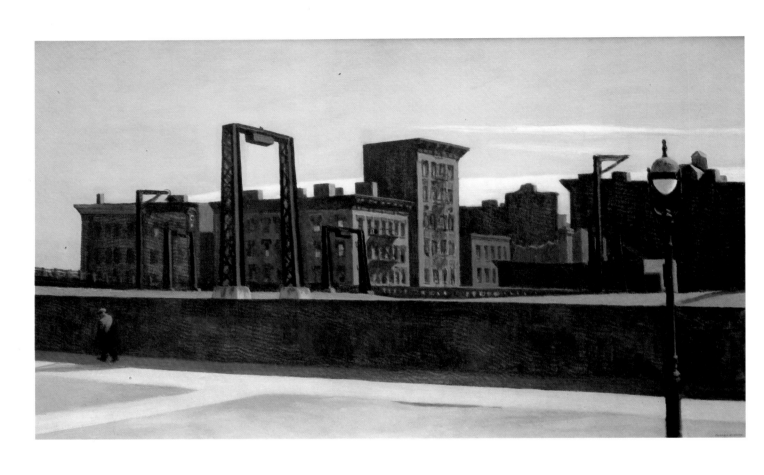

**Manhattan Bridge Loop**

1928

oil on canvas

88.9 × 152.4 cm.

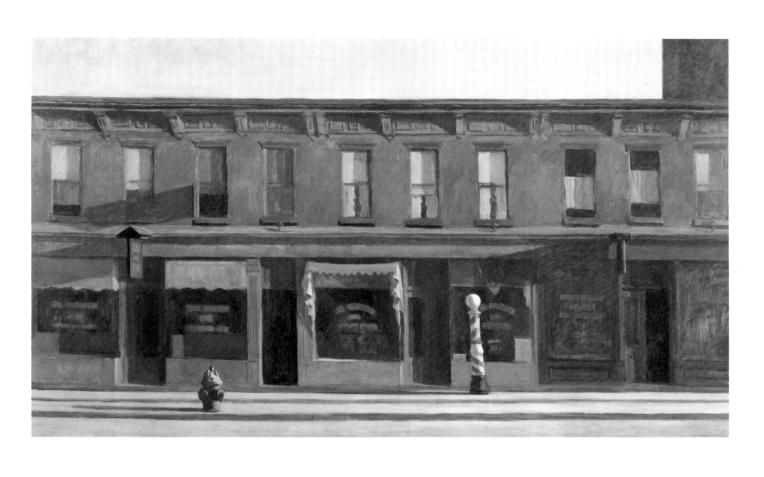

**Early Sunday Morning**

1930

oil on canvas

89 × 152.4 cm.

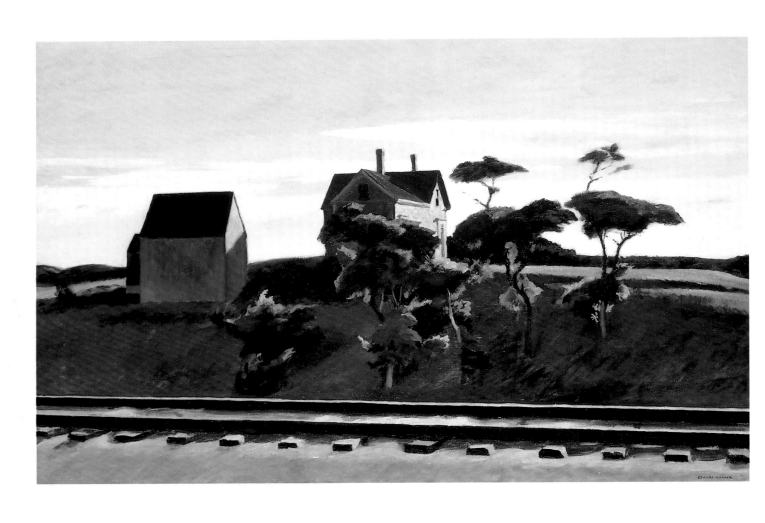

**New York, New Haven and Hartford**

1931

oil on canvas

81.2 × 127 cm.

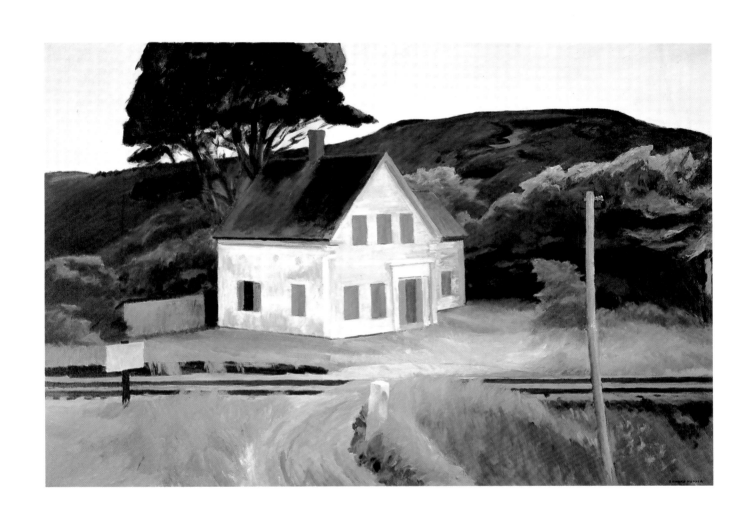

**Dauphinée House***
1932
oil on canvas
86.4 × 127.6 cm.

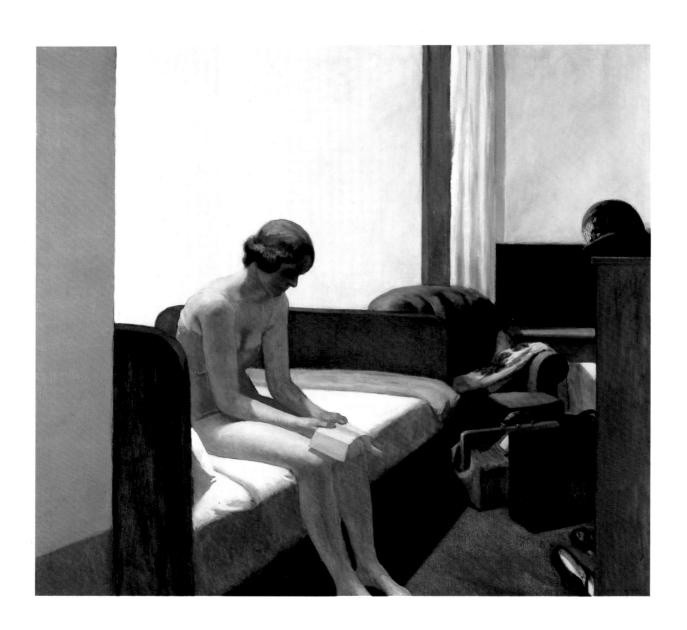

**Hotel Room**
1931
oil on canvas
152.4 × 165.7 cm.

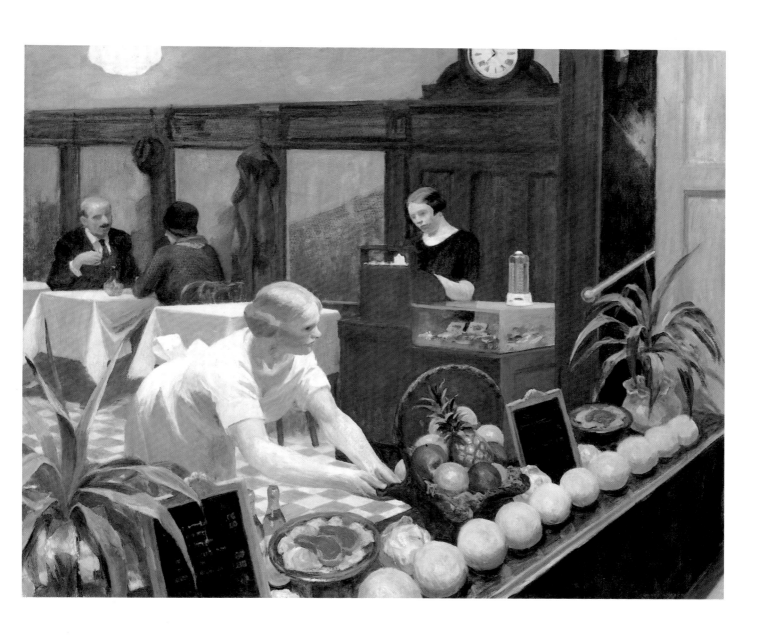

**Tables for Ladies**
1930
oil on canvas
122.5 × 153 cm.

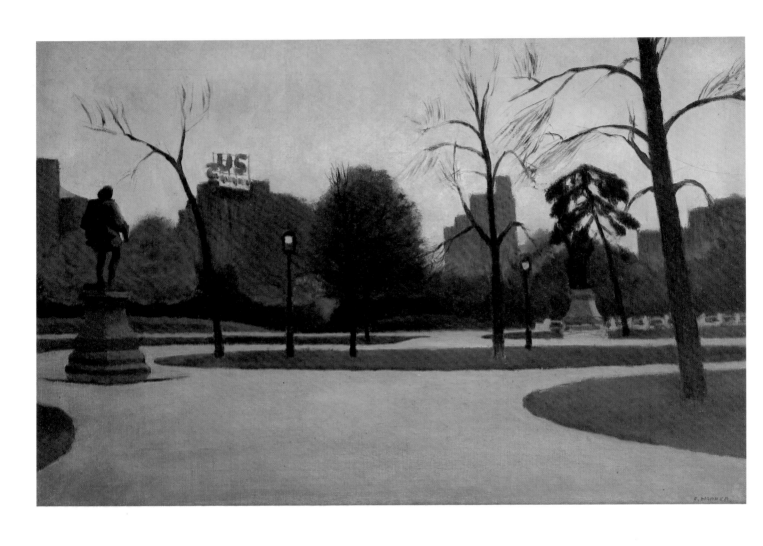

**Shakespeare at Dusk***

1935

oil on canvas

43.2 × 63.6 cm.

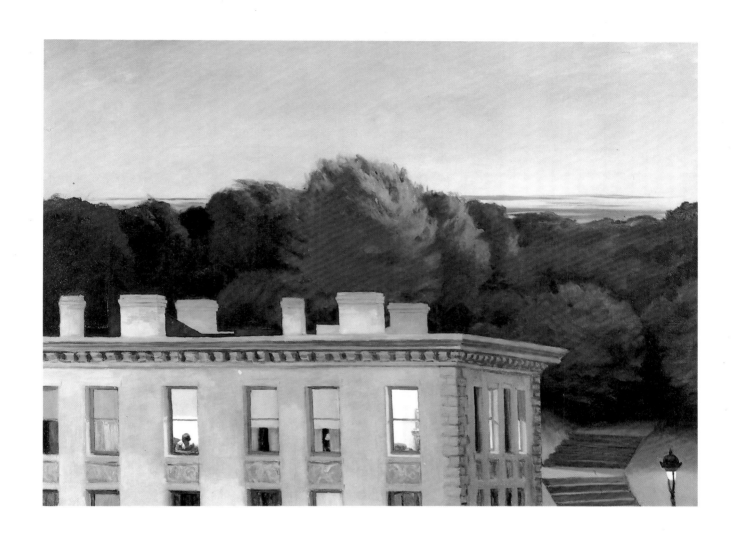

**House at Dusk***
1935
oil on canvas
92 × 127 cm.

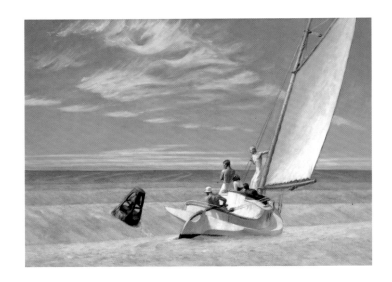

**Ground Swell***

1939

oil on canvas

91.4 × 127 cm.

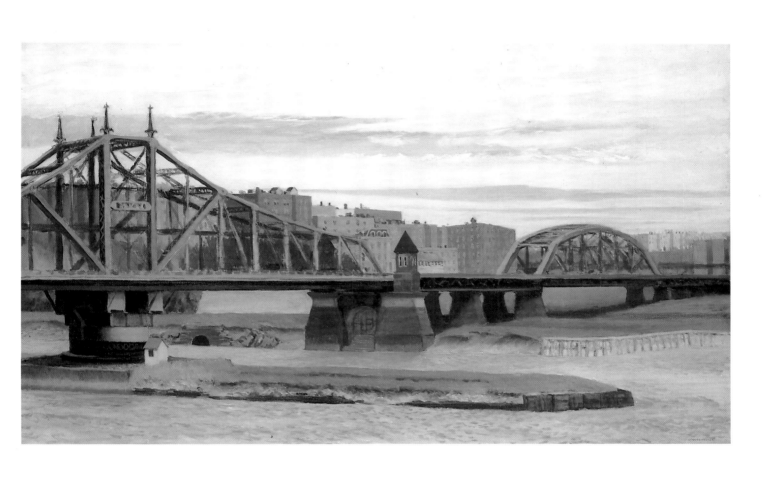

**Macomb's Dam Bridge***

1935

oil on canvas

88.9 × 152.8 cm.

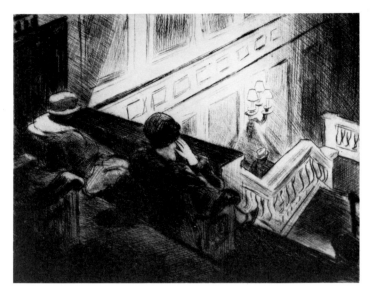

Hopper's constant allusion to cinema is not only rhetorical or structural, but connected to the philosophical problems of evidence, reality, and vision, a modern exploration of Plato's myth of the cave. It derives from the painter's great familiarity with the cinema and also the theater. Like 85 million of his fellow citizens in the late 1930s, Hopper embraced the cinema's art of illusion, an art that allowed the middle class to forget the effects of the Depression and the approaching war. He is fascinated by the universe of New York's theaters—the Strand, the Palace, the Republic, the Globe—dream palaces where monochromatic fictions erase the faded gold of bygone splendor. He documents on several occasions the stylistic evolution of this architecture that grows ever more impoverished (*The Sheridan Theatre*, 1936-1937; *Intermission*, 1963): "When I don't feel in the mood for painting I go to the movies for a week or more. I go on a regular movie binge!" The Whitney Museum keeps a portfolio of the many drawings made in preparation for this major painting: precise studies of the architectural details; rough sketches of the woman moviegoer's outfit; analyses of the usherette's posture; investigations into the painting's composition, its spatial organization, and the placement of the light fixtures. We are able to follow a veritable mise-en-scène that corroborates the notes made by the artist and his wife Jo, in their record books, which describe the painting with brief remarks on the protagonists, often referred to by imaginary names, and their mental states. We know that Jo, a former actress, was the only model used by the painter, who, after studying the natural, everyday movements of his figures, reinvested them with archetypal meaning. Hopper thus combined all the ingredients of the story while taking care not to narrate: "Any more than this, the picture will have to tell, but I hope it will not tell any obvious anecdote, for none is intended." Employing in *New York Movie*, as he often did, a diptych composition (*Cape Cod Evening*, 1939; see pages 78-79), Hopper manages to achieve an amazing complexity by multiplying the light sources, as his wife recorded, and contrasting two spatial progressions: one descending (the red ceiling lights), the other ascending (the stairs with their blue-gray leaf pattern) beyond an opening flanked by two scarlet curtains. The perspective of the shadow isolates an elderly, almost ghostly man and woman, sunk in their far-off seats, and leads us to the disembodied film image, which is perhaps a kiss. The illuminated perspective is the true escape route for this dreamy young usherette, sexy as a starlet. Three figures, three ceiling lights, three lampshades, and a Dionysian column of petrified, gilded vines create an intriguing moment, without narration, yet perfectly explicit.

**The Balcony***
1928
drypoint
33.02 × 43.18 cm.

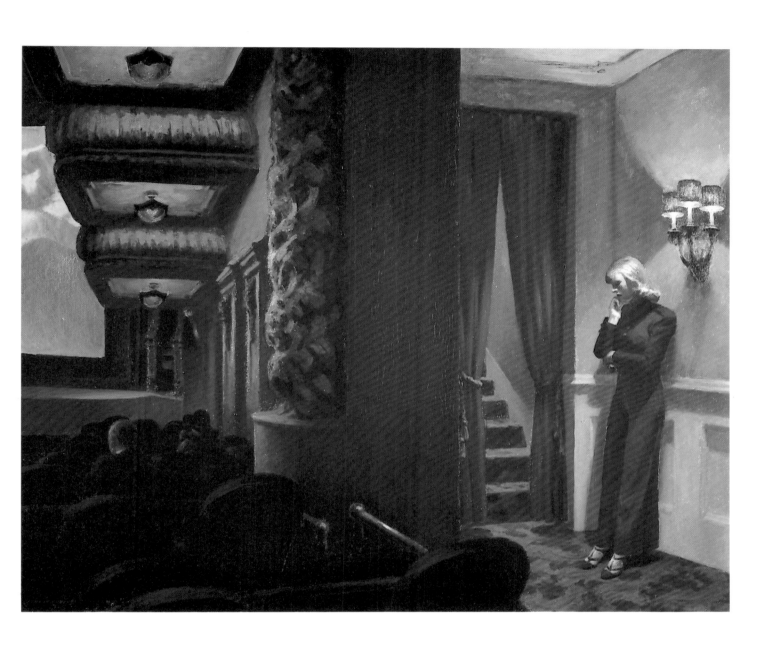

New York Movie*
1939
oil on canvas
81.9 × 101.9 cm.

Drawing for painting
**Cape Cod Evening***
1939
black Conté crayon on paper
21.6 × 27.9 cm.

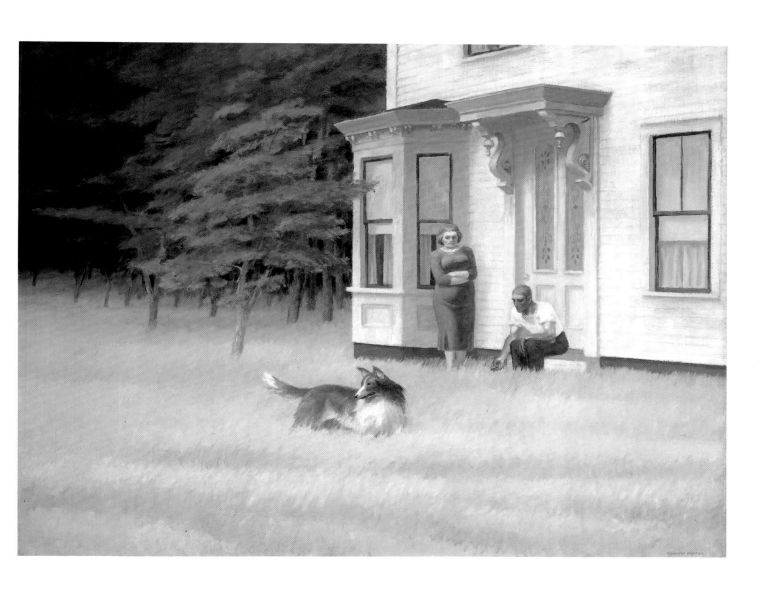

**Cape Cod Evening***
1939
oil on canvas
76.8 × 102.2 cm.

Drawing for painting
**Office at Night No. 2\***
1940
black Conté crayon and charcoal
with touches of white on paper
38.42 × 46.67 cm.

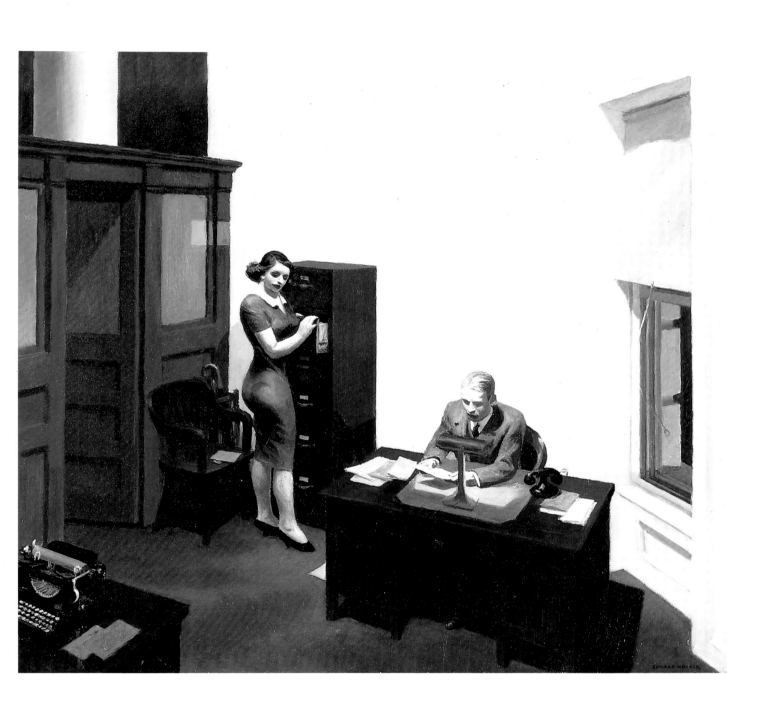

**Office at Night***
1940
oil on canvas
56.2 × 63.5 cm.

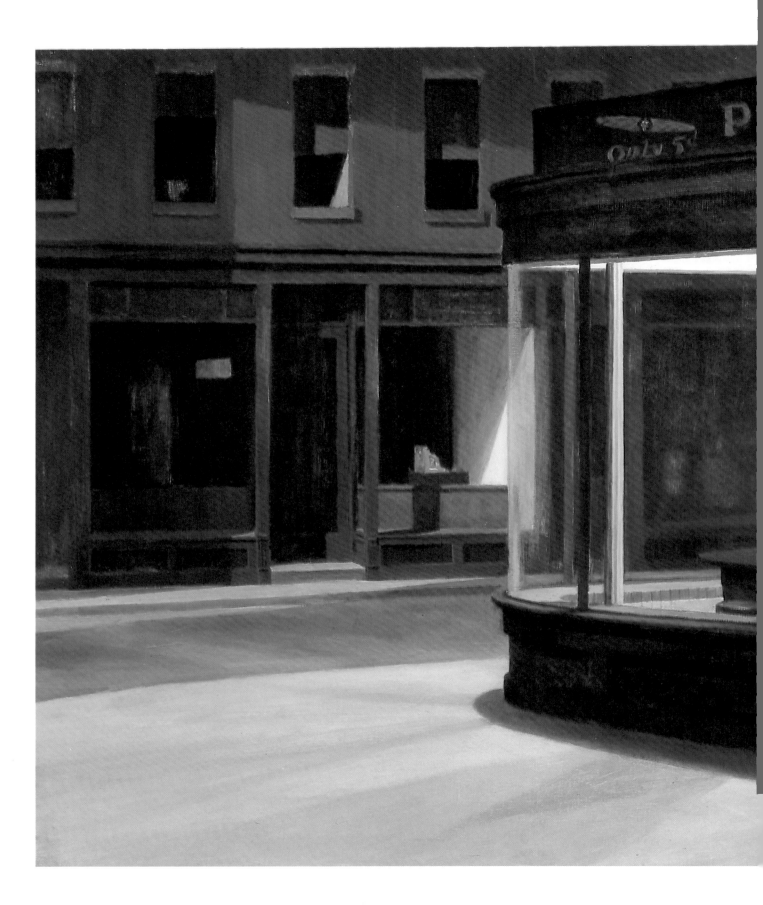

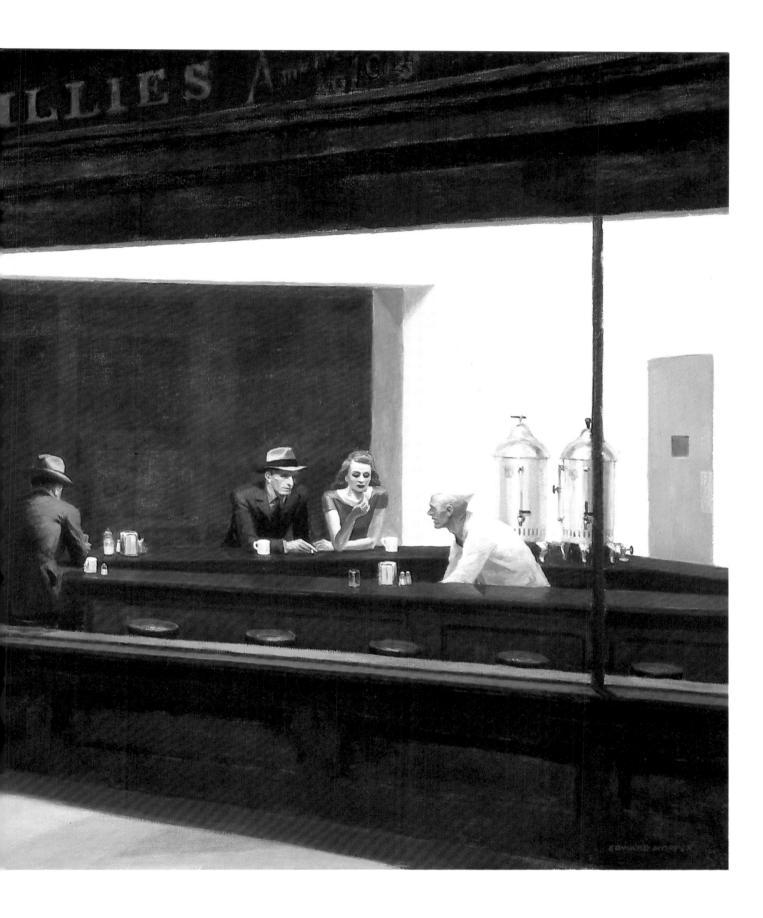

**Nighthawks**
1942
oil on canvas
76.2 × 144 cm.

Edward Hopper loves to depict the seasons and times of day, especially when the light changes and the shadows lengthen, before the sun flattens everything or the night falls. His vision is of a nature that is extreme, sometimes troubling, always vibrant even in the heart of the city (*Shakespeare at Dusk*, 1935; see page 72). The metaphysical feeling of a no-man's-land, of finitude that characterizes this unsettled light, contributes to the indictment of a destructive industrial world, a world that is fast replacing the wide open American spaces and the primeval paradise of the Hudson River School (Frederic Edwin Church, Albert Bierstadt) with a nature henceforth oppressive and inanimate (*East River*, 1920–1923). Between March and July 1941, Jo and Ed Hopper drove through the beautiful American countryside, from Colorado to Nevada, from Wyoming to the East Coast. After this long road trip, the rail depot we see here in *Dawn in Pennsylvania* appears as in a death scene that the slanting light of morning cannot enliven. The engine-less train seems paralyzed before the sad exteriors and empty windows of factory buildings bristling with exhaust pipes and smokestacks. The rails, which throughout Hopper's work express space and time, lose their symbolic dynamism here and simply participate in the painting's very skillful geometric ordering, with its interplay of empty and full planes, of diagonals and verticals reminiscent of Renaissance *cassone*. Like de Chirico's work during the melancholy age just before and during World War I, it is the antithesis of the ideal city that the humanists conveyed to the western world. Through this purposely limited and enclosed staging, Hopper renounces completely the pictorial gusto that had earlier prompted illustrator Rockwell Kent, his classmate at the New York School of Art, to describe him as "the John Singer Sargent of the class." Instead, Hopper conjures up the same apocalyptic feeling that we find in the train stations painted at the same time by Paul Delvaux, amidst the despair of the Occupation. Here, however, the stage is all but deserted; its sole actor is infinite, immobile Time. This extraordinarily theatrical sense of expectation is perhaps even stronger in the Whitney Museum's large preparatory drawing, which strangely presages, in its use of Conté crayon and violent contrasts, those that Bob Wilson creates today for his performances, which also have time as their principal subject.

**Dawn in Pennsylvania***

1942

oil on canvas

62.2 × 113 cm.

Drawing for painting

**Morning in a City***

1944

black Conté crayon on paper

21.6 × 27.9 cm.

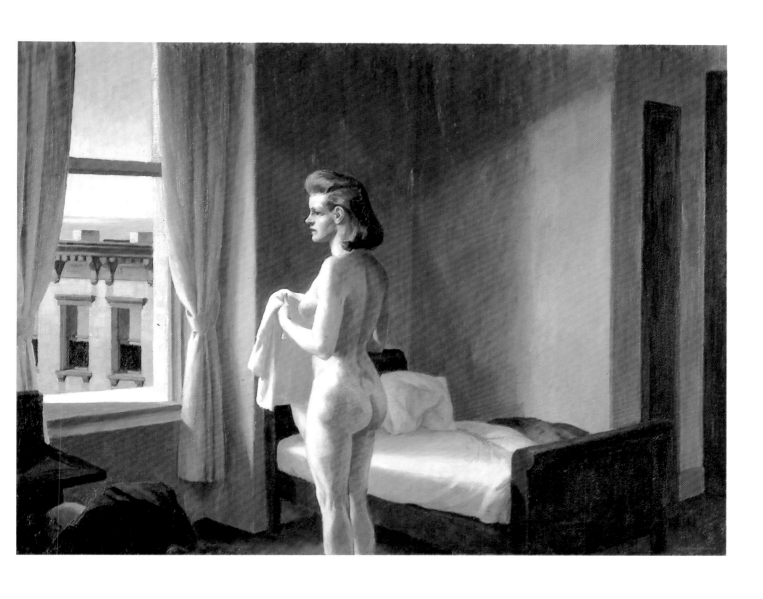

Morning in a City*
1944
oil on canvas
111.8 × 152.4 cm.

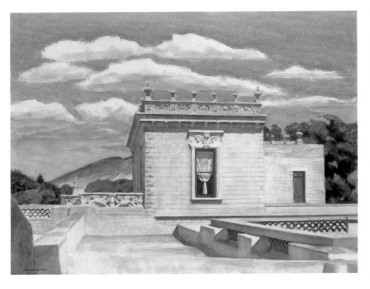

Throughout his career, Edward Hopper painted the familiar landscapes of his country, with a particular predilection for the sea (*Ground Swell*, 1939; see page 74) and the bare expanses of Cape Cod, where he spent many summers before eventually building a house there. These landscapes afforded him the opportunity to evoke with great lyricism the immensity of a pristine nature, the velvety fields, the shimmering rhythms of shadows and light on the rolling hills. His point of view was still the realism of painters like Thomas Eakins and Winslow Homer, exalting the union of man and nature, even if the isolation of a farmhouse or the wake of a railroad track suggested the precariousness of this fusion (*Hills, South Truro*, 1930, Cleveland Museum of Art).

There are six paintings, however, spaced intermittently from 1939 to 1960, that give a completely different reading of the relationship between man and nature: *Cape Cod Evening* (1939, see pages 78–79); *August in the City* (1945, see page 89); *Seven A.M.* (1948, see page 94); *High Noon* (1949, see page 14); *Cape Cod Morning* (1950); and *Second Story Sunlight* (1960). With the exception of *High Noon*, whose skillful geometry is based on the horizontal of the prairie, all of them are composed as diptychs. The polarized, schizophrenic confrontation in the other pictures presents a very specific house opposing indistinct trees on the edge of a wood, which are blanketed in a darkness so impenetrable that the sun in its daily course barely grazes it. In *Cape Cod Evening*, the dog, turning away from his owners perhaps to listen to the sound of a bird, attests to this ruptured relationship between man and nature. His masters, self-absorbed, seem to cut themselves off from life, to be incapable of leaving their house with its sightless windows and to be indifferent to the trees advancing through the grass "in phalanx position" (according to a note of Jo's). Oddly placed in the foreground of the canvas, the house in *August in the City*, with its rotundalike curve serving as a sort of sundial and accentuating the inevitability of time and death, makes clear that the rupture of this traditional harmony is due to the loss of cultural identity. We find this in the heterogeneous references to a world that is past: the neo-Gothic entrance, the baroque fireplace, and the strange gilt bronze praying figure, which give an esoteric character to this parable.

**Saltillo Mansion***
1943
watercolor on paper
54 × 68.6 cm.

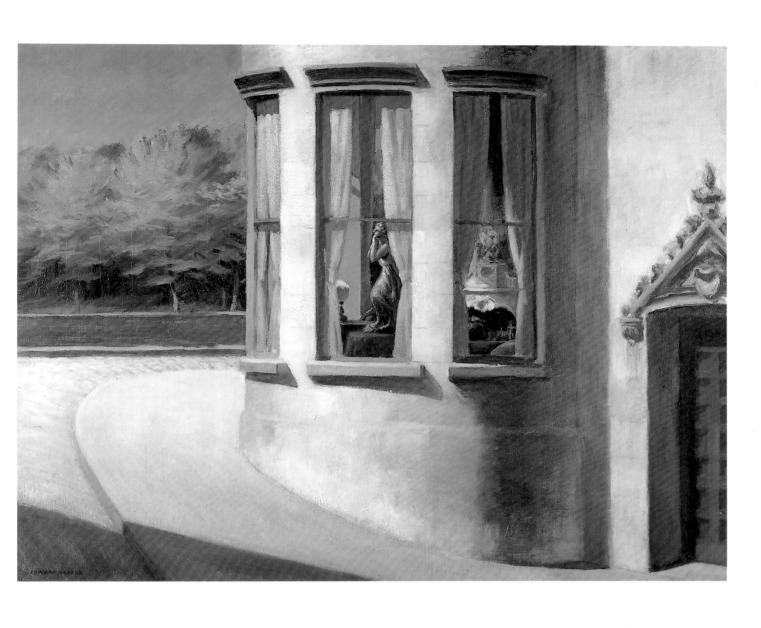

**August in the City***

1945

oil on canvas

58.4 × 76.7 cm.

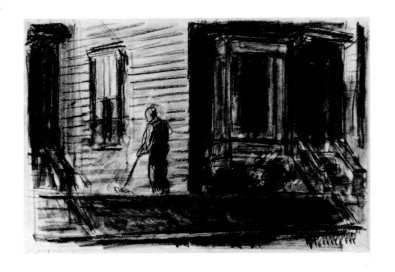

Drawing for painting

**Pennsylvania Coal Town***

1947

black Conté crayon on paper

28.26 × 38.1 cm.

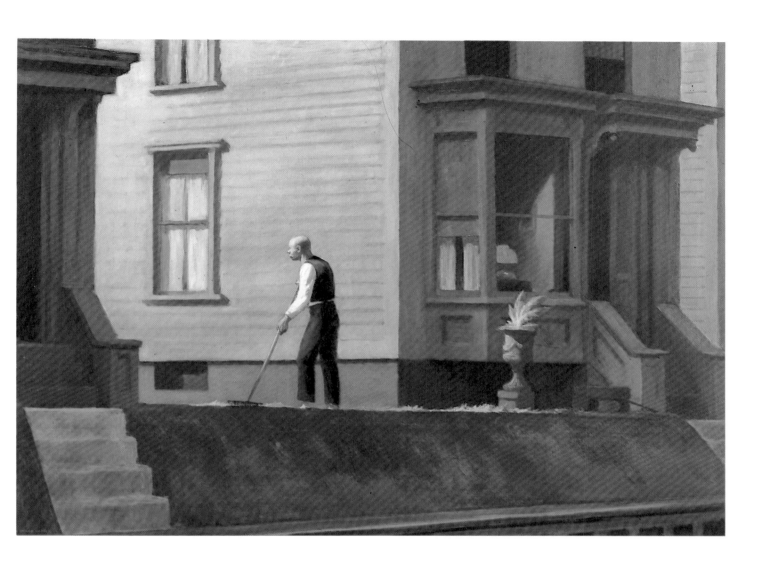

**Pennsylvania Coal Town***

1947

oil on canvas mounted on hardboard

71.1 × 101.6 cm.

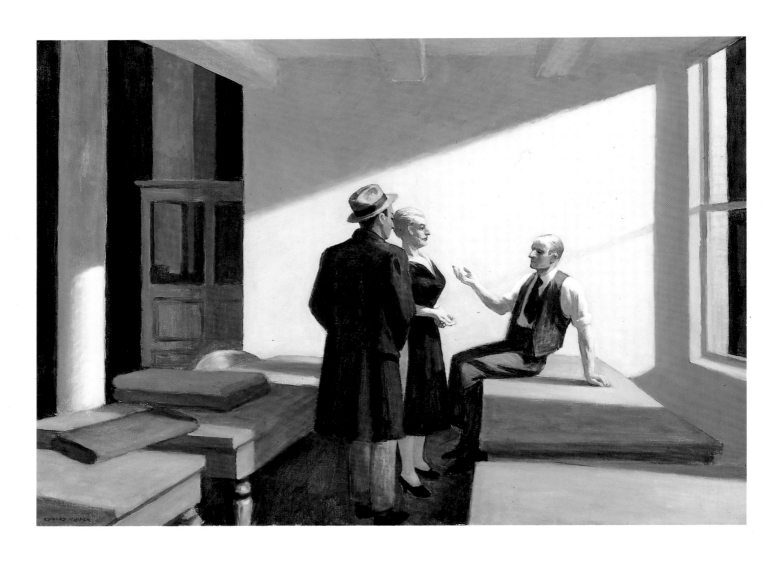

**Conference at Night**

1949

oil on canvas

70.5 × 101.6 cm.

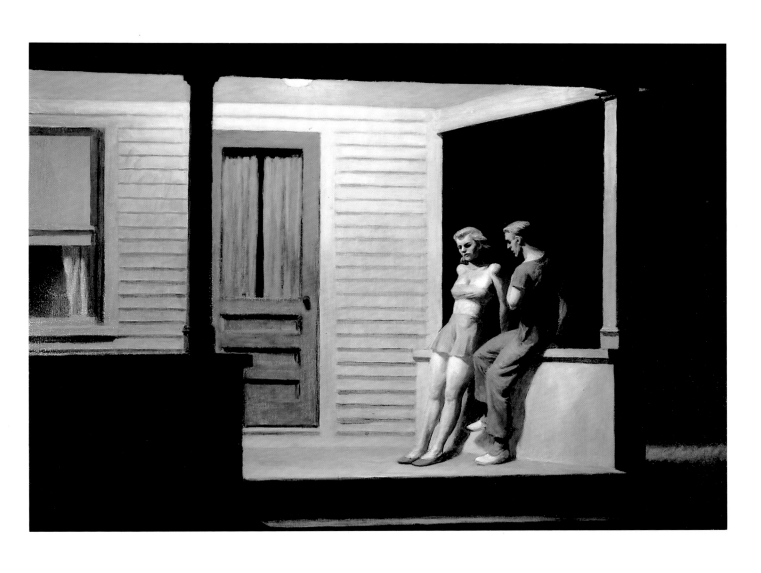

**Summer Evening**
1947
oil on canvas
74 × 111.8 cm.

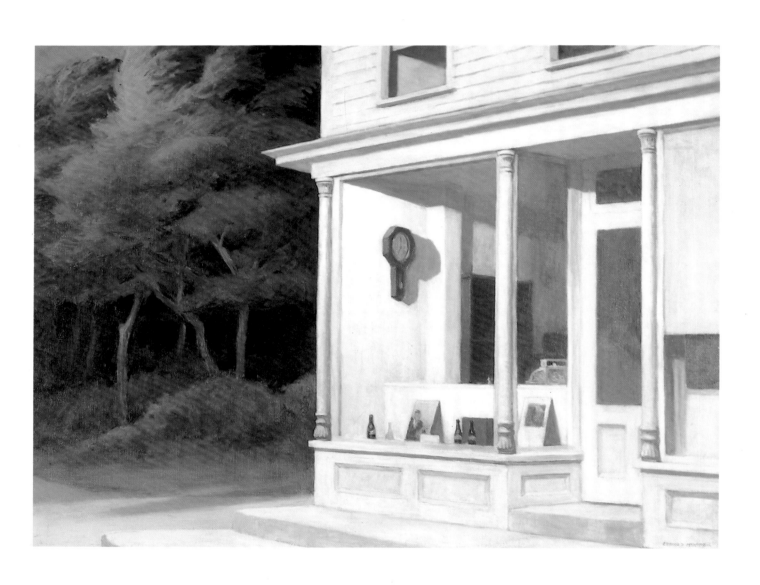

**Seven A.M.**
1948
oil on canvas
76.2 × 102 cm.

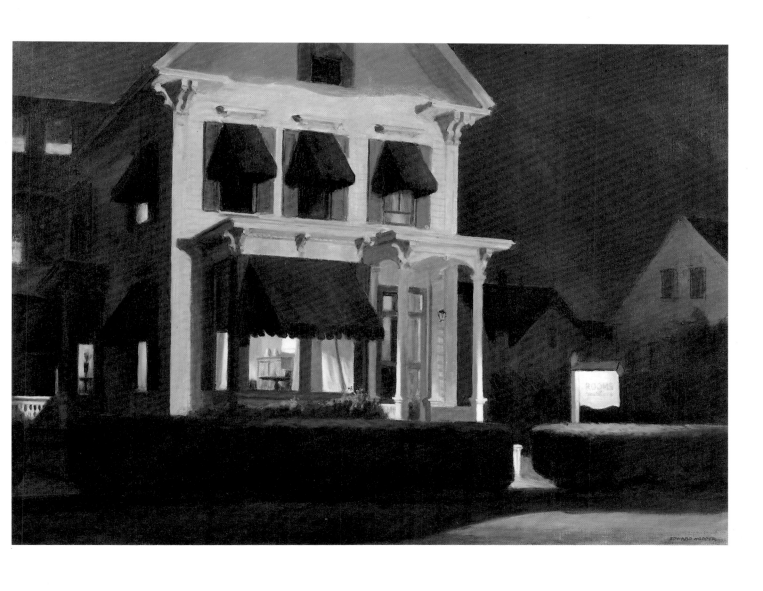

**Rooms for Tourists\***

1945

oil on canvas

76.8 × 107 cm.

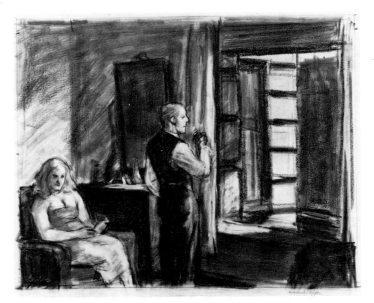

The painting, *Hotel by a Railroad*, is divided exactly in half by the man who is standing, smoking meditatively. On the right, the exterior; on the left, the interior. On one side there is the light source that illuminates the two figures (a horizontal fragment of the infinite), the section of track, and the regular vertical ladder of the stone facing. That brightness contrasts with the dark, sightless façade, which is dominated by a chimney, a chimney broken by its shadow. The woman, elderly like her companion, is reading. Perhaps the book is a Bible, perhaps the Gideon's left in every American hotel room. Perhaps she ponders Jacob's dream and the search for a new covenant. We almost see Jacob's ladder in the mirror, which reflects the abstract diagonals of the room. Edward Hopper's work resists the anecdotal and demands interpretation. It is compelling as an enigma and leads us in its mental intrigue from painting to painting. Reading is a frequent theme in his painting from the 1930s on and is often linked to the evocation of travel (*Compartment C, Car 293*, 1938, IBM Corp., New York; *Hotel Lobby*, 1943, Indianapolis Museum of Art; *Chair Car*, 1965, private collection). It seems here to offer an alternative to loneliness, to provide solutions to the mystery of existence. We contemplate, before this solitary duo, the "fundamental truth" that Hopper saw in Ibsen's characters. And we behold an internalized realism that the painter may have found in Samuel Beckett's texts. This triangle, comprising an interrogation of the individual, a selection of simple, yet strongly connotative objects, and a spiritualized space, represents one of the strong currents of 1950s sensibility—one that includes the Europeans Morandi, Balthus, Jean Hélion, and Alberto Giacometti, who are too often obscured by the flood that is abstraction.

Drawing for painting
**Hotel by a Railroad***
1952
black Conté crayon on paper
48.3 × 30.4 cm.

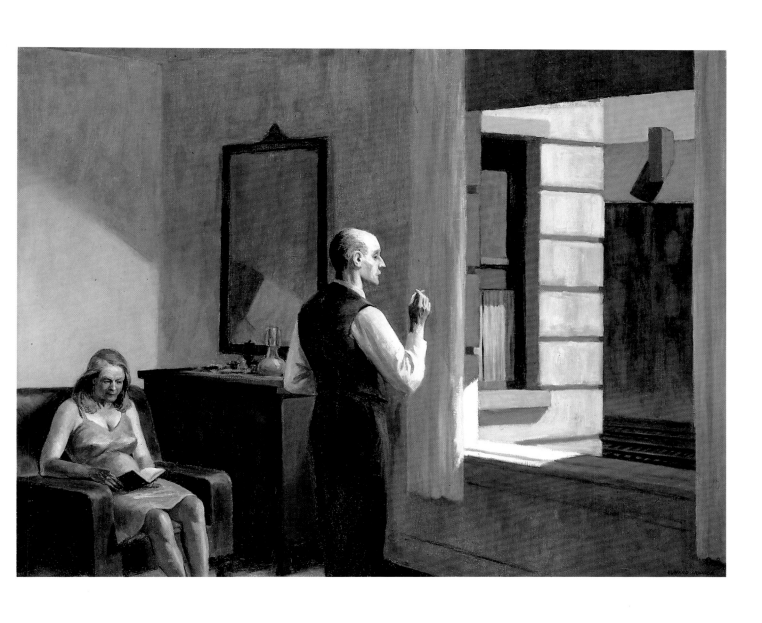

**Hotel by a Railroad***
1952
oil on canvas
72.2 × 101.8 cm.

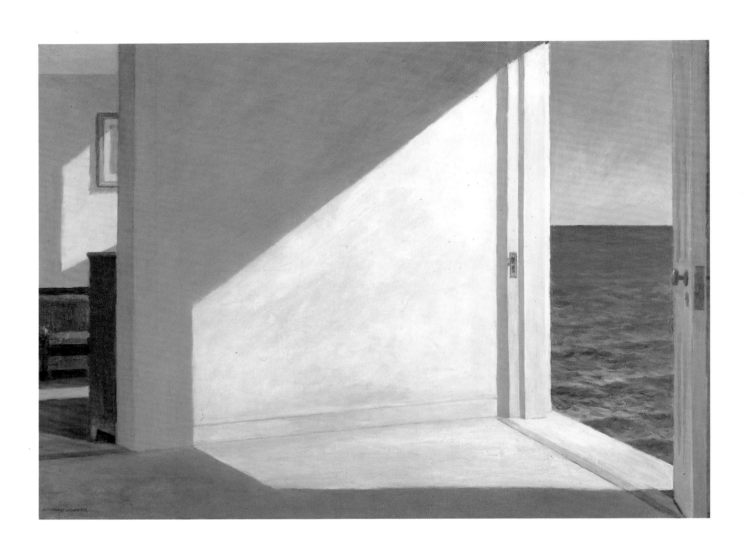

**Rooms by the Sea**

1951

oil on canvas

73.7 × 101.6 cm.

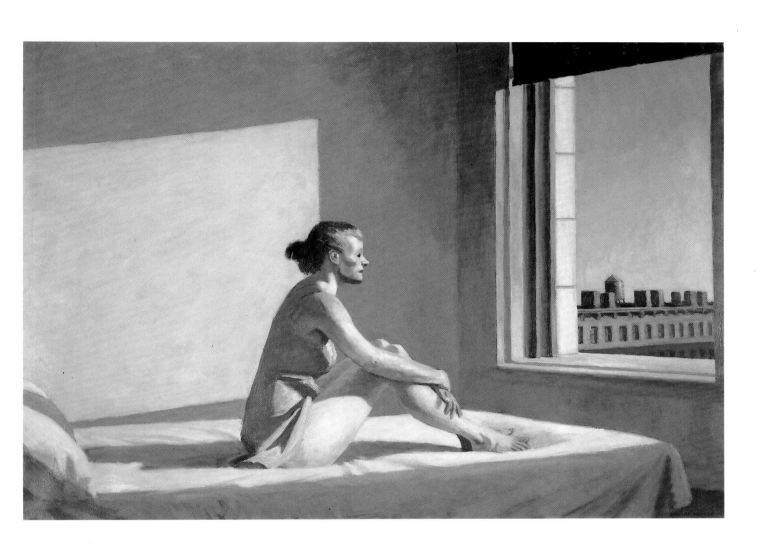

**Morning Sun***
1952
oil on canvas
71.4 × 101.9 cm.

Adopting the point of view of a movie crane shot in *Office in a Small City*, Hopper confers a great strangeness on both this urban landscape and the figure we observe. The figure is himself an observer, caught between two picture windows without glass that seem to serve as screens, one for us and one for him. The imaginary triangular space, thus suggested, formally and psychologically animates the painting in which two universes meet, that of the architecture of the past—the turn-of-the-century building, with its arched windows and pilasters, a fragment of a curving pediment—and the antiseptic neutrality of a contemporary space, characteristic of the 1950s, in which a sort of human robot is in charge. This extremely elaborate composition of geometric planes results from a slow, intuitive process of approximation that seeks to restore a profound existential sentiment; it occupies the opposite end of the spectrum from the formal simplifications that the 1920s mechanists, such as Charles Demuth and especially Charles Sheeler, extracted from the objective practices of photography and cinema. Hopper, more than ever, rejects the modernist and mechanist exaltation that Sheeler and Paul Strand conveyed in their 1920 film *Mannahatta*. He was interested in the middle classes of the American heartland, but they have surmounted the adversities of earlier decades, perceptible in *Sunday* (The Phillips Collection, Washington, D.C., 1926), a painting that also suffers through a sweltering summer heat. Hopper is less bound than ever to the social compassion of the Ashcan school that his teachers Robert Henri and John Sloan had instilled in him. The businessman of 1953 bears a curious resemblance to those that Hopper drew in 1912 to illustrate a manual of sales techniques (Carrol D. Murphy, "What Makes Men Buy?" *System*, September 1912). But it is the spiritual impoverishment of modern man, his irremediable emptiness that this evangelical pessimist will henceforth denounce, bathing his hopeless figures in a light whose metaphysics remains enigmatic (*Excursion into Philosophy*, 1959, private collection).

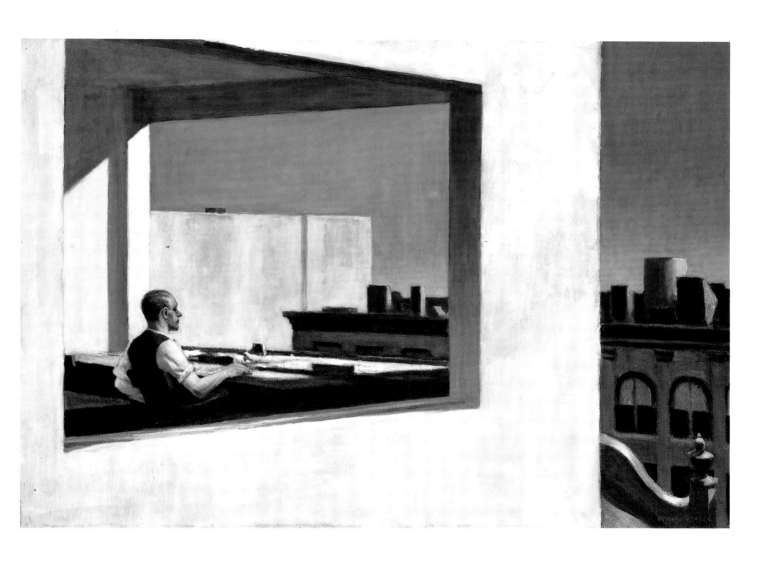

**Office in a Small City***
1953
oil on canvas
71.7 × 101.6 cm.

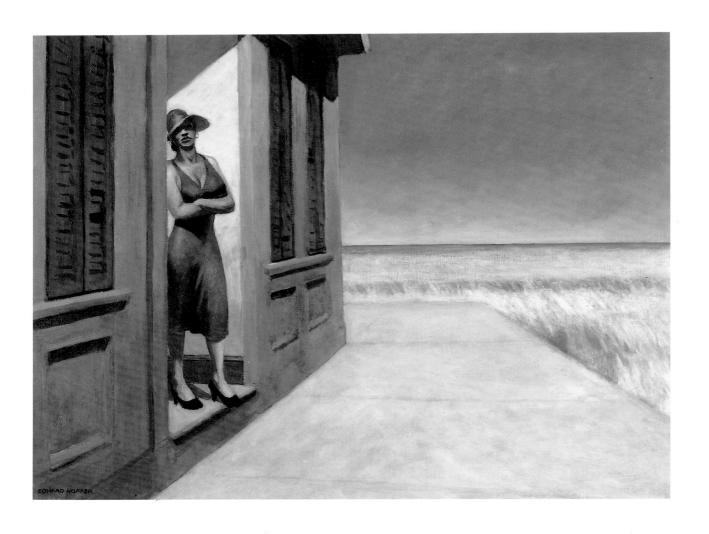

**Carolina Morning**

1955

oil on canvas

76.2 × 102 cm.

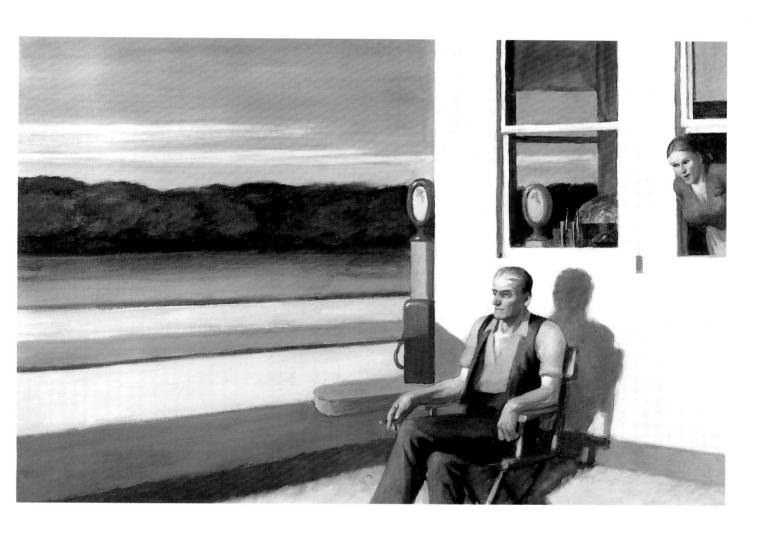

**Four Lane Road**
1956
oil on canvas
69.8 × 105.4 cm.

It is once again the painful dialogue between mortal being and immutable nature that Edward Hopper seeks to reconstruct in this depressing symbolic picture of waiting. While a civilization of leisure asserts itself and little by little replaces that of work, Hopper describes with an objective cruelty the worshipful posture and mental stupor of a new cult—the sun worshippers. The resulting angst in *People in the Sun* surpasses that produced by the images of sexuality and death that Winslow Homer painted at the end of the last century (A *Summer Night*, 1890, Musée d'Orsay, Paris; *The Gulf Stream*, 1899, Metropolitan Museum of Art, New York). Far from the passionate lyricism of man's struggle against nature unbound, Hopper presents here an image of submission before a horizon fenced in by dreary hills. Only the reader, seated to the rear, allows us to hope for the refuge of culture. The countries of eastern Europe, with their "Socialist Realism," make their sacrifices to the cult of the workers' collective effort. Hopper, meanwhile, depicts the isolation of the individual within the group and produces this disturbingly misanthropic scenography of solitude, of the ages of man (*Second Story Sunlight*, 1960, Whitney Museum of American Art, New York), and of death. His pessimism is more radical than that which reigned in American art on the eve of World War II, and it is especially at odds with the postwar establishment, which favored adopting the more positive and less antiauthoritarian action painting (*cf.* Serge Guilbaut, *How New York Stole the Idea of Modern Art*, 1983). Edward Hopper never joins in the social or political militancy of a Reginald Marsh, preferring always to pursue a universal symbolic dimension. While he opposes abstraction vehemently, joining (under the aegis of *Reality*) the protests of realist artists against the Whitney's nascent preference for abstraction, Hopper declares in his own fashion the emblematic power of form. Each structural element serves, in fact, to underline the spiritual meaning of the painting. The social corps of figures situated in the byplay of criss-crossed chair segments and shadows, the repetitive parallelism of the bodies inscribed in a triangle of light, the perpendicular meeting of furniture and horizon—everything works to bring out the silent inexorability of an anonymous contemporary drama.

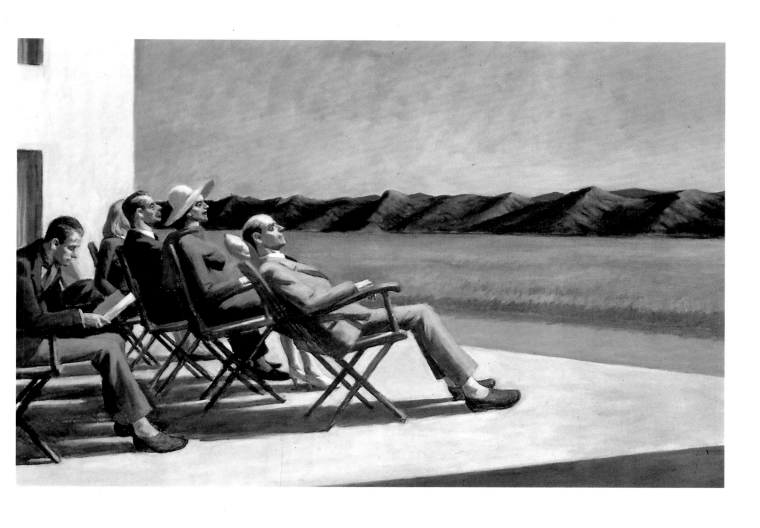

**People in the Sun***
1960
oil on canvas
102.6 × 153.5 cm.

Now at the Musée Cantini, in Marseilles, this drawing is the first work by Edward Hopper acquired by a European public collection. That such a purchase should first occur in 1988 illustrates the isolation of the artist, who, despite his aspirations to the universal, found himself confined in the pigeonhole of the American Scene with lesser artists like Charles Burchfield and Glenn O. Coleman. This reductivism was due to the rise of artistic nationalism, a consequence of the Depression and, later on, of Abstract Expressionism, which, in search of international influence, opposed the hegemony of French art and impugned, through both blindness and strategy, powerful and remarkable realists like Ivan Le Lorraine Albright in Chicago and Edward Hopper in New York. Overlooked by the defenders of contemporary art, Hopper had for consolation, however small, the numerous distinctions and medals accorded him by American academic organizations.

This drawing is a study for *Sun in an Empty Room*, one of the artist's most moving paintings done in the twilight of his life. It is essentially a metaphysical work and counts among his last manifestos on the reflective character of the work of art—reflective both as a mirror of the external world and as an introspective attempt at spiritual synthesis. It is a serene farewell, like that of the white-faced clowns who, in *Two Comedians* (1965, private collection), may represent the last bow of the painter and his wife to the art world and to life itself. An empty room is structured by the light with this ubiquitous dark greenery, which, even on the stage of *Two Comedians* and in the equally bare *Road and Trees* (1962, private collection), evokes the occult powers of nature. The female figure who seems to hope for illumination in *Morning Sun* (1952; see page 99) or in *A Woman in the Sun* (1961, Whitney Museum of American Art, New York) has here disappeared.

In his own way, Edward Hopper attains the "sublime" that abstract spiritualists like Mark Rothko and Barnett Newman were also searching for at the time. All of Hopper's craft as a draftsman appears here, pared to the essential, feverish in its intuition of the concept, quick and precise, privileging the emotional dialogue of shadow and light, comparable to Alberto Giacometti's drawings in its approach to the physical world. The coincidence is striking if we think of the sculptor's comments after his single trip to America: "I have hardly looked at the sea since I saw, two days ago, the extreme tip of New York dissolve, disappear, slender, fragile and ephemeral on the horizon, and it is as if I were living the beginning and the end of the world, an anguish grips my chest, I feel only the sea that surrounds me, but there is also the dome, the immense vault of a human head" (1965; in *L'Ephémère*, No. 1, p. 105).

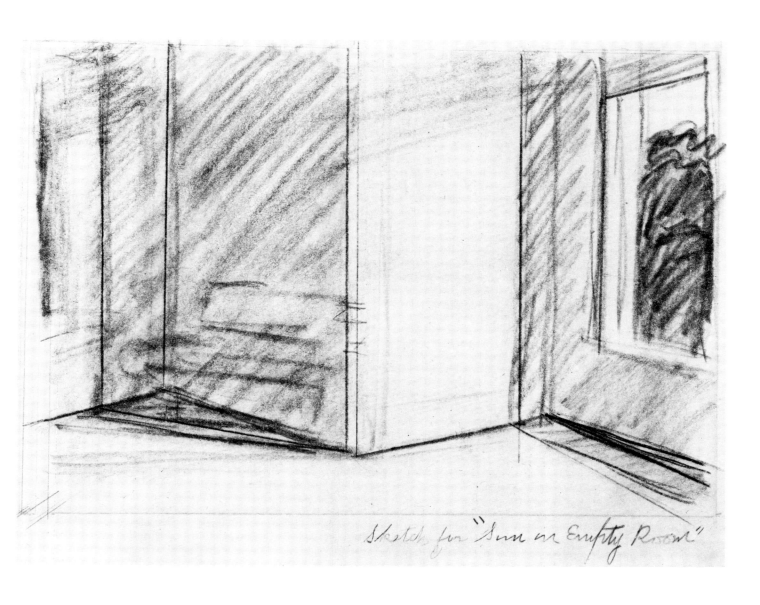

Sketch for "Sun in Empty Room"

Drawing for painting
**Sun in an Empty Room***
c. 1963
charcoal on beige paper
31 × 37.8 cm.

# Brief Chronology

**1882**

Edward Hopper is born in Nyack, New York, where he attends a private day school, then high school.

**1899–1906**

After studying briefly at the Correspondence School of Illustrating, he enrolls at the New York School of Art in order to complete his training in illustration and to take painting classes with Robert Henri, William Merritt Chase, and Kenneth Hayes Miller. His fellow students include George Bellows, Patrick Henry Bruce, Guy Pène du Bois, Rockwell Kent, and Walter Pach.

**1906**

Having worked briefly as an illustrator in New York, he goes in October 1906 to Paris, where he lives until August 1907. In the meantime he visits London, which disappoints him but where he discovers the National Gallery and the Wallace Collection. He travels also to Amsterdam and Haarlem, where he is particularly impressed by Rembrandt and Hals, then goes on to Berlin and Brussels. In 1908 he shows his first Paris works in New York at a group show in the old Harmony Club building.

**1909**

After returning to Paris in March, he paints out-of-doors on the banks of the Seine, then visits Fontainebleau and Saint-Germain-en-Laye before returning to New York in July.

**1910**

In May he visits Paris en route to Madrid and Toledo, and stops there again in July on his way back to New York, where he earns his living as a commercial artist and illustrator and devotes his free time to painting.

**1912**

He shows his Paris paintings at a group exhibition at the MacDowell Club of New York. He spends the summer in Gloucester, Massachusetts, where he paints in the company of Leon Kroll.

**1913**

He exhibits an oil at the Armory Show in February; in March, he makes his first sale and moves to 3 Washington Square North in Greenwich Village, where he will live until his death.

**1915**

He takes up etching. In February he shows *Soir Bleu* and *New York Corner* at the MacDowell Club of New York. From 1915 through 1919 he summers in Maine, spending the first summer in Ogunquit and the rest on Monhegan Island.

**1918**

Hopper wins first prize in a national contest sponsored by the United States Shipping Board Emergency Fleet Corporation with his poster *Smash the Hun.*

**1920**

Hopper has his first one-man show at the Whitney Studio Club, with oils painted in Paris and on Monhegan Island.

**1922**

He shows ten Parisian caricatures done in watercolor, again at the Whitney Studio Club, where the following year he will take evening classes in life drawing.

**1923**

Although, since 1919, Hopper has shown his prints in specialized group exhibitions (Chicago Society of Etchers, International Printmakers Exhibition, Brooklyn Society of Etchers, etc.), he abandons etching and takes up watercolor at the urging of Josephine Verstille Nivison, who becomes his wife in 1924. This year, the Brooklyn Museum purchases *The Mansard Roof* for $100.

**1925–1927**

Hopper takes several trips into the American countryside, venturing into Maine, New Hampshire, Vermont. In 1927, he buys an automobile. Though he continues to show his Paris paintings

(Boston Art Club, 1926), American themes assert themselves in his work.

## 1928
He executes his last print, a drypoint portraying his wife, Jo.

## 1929-1932
Hopper visits friends in South Carolina, Maine, and Massachusetts. In South Truro, on Cape Cod, he rents a house that he nicknames "Bird Cage Cottage." In January-February 1929, he is featured in a one-man show at the Frank K. M. Rehn Gallery. Elected associate member of the National Academy of Design in 1932, Hopper refuses the honor because the Academy had rejected his earlier paintings.

## 1933
After a trip to Quebec, Hopper and his wife buy some land in South Truro and build their house-studio. Henceforth, they go there every summer. He has his first retrospective exhibition at the Museum of Modern Art in New York with 25 oils, 37 watercolors and 11 etchings (article by Alfred Barr).

## 1934
He has a retrospective at the Arts Club of Chicago. Hopper receives many official distinctions during the following years and is a member of the jury of the Carnegie Institute in 1939.

## 1940
Hopper votes for Wendell Willkie.

## 1941
He drives across the United States, traveling to Colorado, the Nevada desert, California, and Wyoming.

## 1943
Hopper makes his first trip to Mexico, by train (Mexico City, Saltillo, Monterrey).

## 1945
Hopper is elected member of the National Institute of Arts and Letters.

## 1946
He revisits Mexico, this time by car, and paints four watercolors in Saltillo, where he will return in 1951.

## 1950
The retrospective exhibition of his work organized by the Whitney Museum of American Art later travels to Boston's Museum of Fine Arts and the Detroit Institute of Arts.

## 1952
Chosen by the American Federation of Arts, along with three other American artists, Hopper represents the United States at the Venice Biennale. He returns to Mexico.

## 1953
He joins Raphael Soyer and other representational artists on the editorial board of the publication *Reality*.

## 1955
The Gold Medal for Painting is awarded to Hopper by the National Institute of Arts and Letters in the name of the American Academy of Arts and Letters.

## 1956
He becomes a Fellow of the Huntington Hartford Foundation in Pacific Palisades, California.

## 1959
The one-man exhibition organized by the Currier Gallery of Art in Manchester, New Hampshire, is shown also at the Rhode Island School of Design in Providence.

## 1960
After receiving the *Art in America* Annual Award, Hopper attends a meeting at the home of John

Koch with a group of other contributors to *Reality*. The purpose: to protest the overrepresentation of abstract artists at the Whitney Museum of American Art and the Museum of Modern Art.

## 1962

The catalogue raisonné of his prints is published on the occasion of his exhibition *The Complete Graphic Work of Edward Hopper*, at the Philadelphia Museum of Art.

## 1964

Weakened by illness, he is unable to paint. The Whitney Museum organizes a major retrospective, which later travels to the Art Institute of Chicago (introduction by Lloyd Goodrich).

## 1965

His sister, Marion, dies in Nyack. He completes his final canvas, *Two Comedians*.

## 1967

Edward Hopper dies May 15 in his New York studio.

# Selected Bibliography

## Monographs

Goodrich, Lloyd. *Edward Hopper.* Harmondsworth: Penguin Books, 1949.

Goodrich, Lloyd. *Edward Hopper.* New York: Abradale Press/Harry N. Abrams, Inc., 1983.

Hobbs, Robert. *Edward Hopper.* New York: Harry N. Abrams, Inc., in association with the National Museum of American Art, Smithsonian Institution, 1987.

Levin, Gail. *Edward Hopper as Illustrator.* New York: W. W. Norton & Co., in association with the Whitney Museum of American Art, 1979.

——. *Edward Hopper: The Complete Prints.* New York: W. W. Norton & Co., in association with the Whitney Museum of American Art, 1979.

——. *Edward Hopper: The Art and the Artist.* New York: W. W. Norton & Co., in association with the Whitney Museum of American Art, 1980.

——. *Edward Hopper.* Paris: Flammarion, 1985.

——. *Hopper's Places.* New York: Alfred A. Knopf, 1986.

Liesbrock, Heinz. *Edward Hopper: Quarante Chefs-d'oeuvre.* Munich: Schirmer/Mosel, collection "Bibliothèque visuelle," 1988.

## Catalogues

*Three Painters of America: Charles Demuth, Charles Sheeler, Edward Hopper.* New York: The Museum of Modern Art, 1933.

Goodrich, Lloyd. *Edward Hopper.* New York: The Whitney Museum of American Art, 1964.

Seitz, William C., and Lloyd Goodrich. *Edward Hopper: Selections from the Hopper Bequest to the Whitney Museum of American Art.* New York: The Whitney Museum of American Art, 1971.

*America Observed: Etchings by Edward Hopper, Photographs by Walker Evans.* San Francisco: The Fine Arts Museums of San Francisco, 1976.

Goodrich, Lloyd, and Gail Levin. *Edward Hopper at the Kennedy Galleries.* New York: Kennedy Galleries, 1977.

*The Art and the Artist.* London: Hayward Gallery, Arts Council of Great Britain, 1981.

*Edward Hopper: gli Anni della Formazione.* Milan: Electa, 1981.

Dreishpoon, Douglas. *Edward Hopper, Early and Late.* New York: Hirschl and Adler Galleries, Inc., 1987.

Schjeldahl, Peter. *Edward Hopper: Light Years.* New York: Hirschl and Adler Galleries, Inc., 1988.

# List of Illustrations
# Photographic Credits

## Paintings

**Les Lavoirs à Pont Royal***
1907
oil on canvas
59.06 × 72.39 cm.
The Whitney Museum of American Art, New York
Josephine N. Hopper Bequest
70.1247

**Louvre and Boat Landing***
1907
oil on canvas
58.4 × 71.7 cm.
The Whitney Museum of American Art, New York
Josephine N. Hopper Bequest
70.1249

**Après midi de juin***
1907
oil on canvas
59.7 × 72.4 cm.
The Whitney Museum of American Art, New York
Josephine N. Hopper Bequest
70.1172

**The El Station***
1908
oil on canvas
50.8 × 73.7 cm.
The Whitney Museum of American Art, New York
Josephine N. Hopper Bequest
70.1182

**Le Pavillon de Flore***
1909
oil on canvas
59.69 × 72.39 cm.
The Whitney Museum of American Art, New York
Josephine N. Hopper Bequest
70.1174

**Le Bistro** or **The Wine Shop***
1909
oil on canvas
59.37 × 72.39 cm.
The Whitney Museum of American Art, New York
Josephine N. Hopper Bequest
70.1187

**Squam Light**
1912
oil on canvas
61 × 73.70 cm.
Private collection

**New York Corner** or **Corner Saloon***
1913
oil on canvas
61 × 73.7 cm.
The Museum of Modern Art, New York
Abby Aldrich Rockefeller Fund, 1941

**Soir Bleu**
1914
oil on canvas
91.5 × 183 cm.
The Whitney Museum of American Art, New York
Josephine N. Hopper Bequest
70.1208

**Stairway***
1919
oil on wood
40.64 × 30.16 cm.
The Whitney Museum of American Art, New York
Josephine N. Hopper Bequest
70.1265

**House by the Railroad***
1925
oil on canvas
61 × 73.7 cm.
The Museum of Modern Art, New York
Given anonymously, 1930

**Self-Portrait***
1925–1930
oil on canvas
63.82 × 51.44 cm.
The Whitney Museum of American Art, New York
Josephine N. Hopper Bequest
70.1165

**Automat**
1927
oil on canvas
71.5 × 91.5 cm.

Des Moines Art Center
Des Moines, Iowa
James D. Edmundson Fund

**The City**
1927
oil on canvas
70 × 90.4 cm.
University of Arizona Museum of
Art, Tucson, Arizona
Gift of Leonard C. Pfieffer

**Manhattan Bridge Loop**
1928
oil on canvas
88.9 × 152.4 cm.
Addison Gallery of American
Art,
Phillips Academy,
Andover, Massachusetts
Gift of Mr. Stephen C. Clark

**Night Windows***
1928
oil on canvas
73.7 × 86.4 cm.
The Museum of Modern Art,
New York
Gift of John Hay Whitney, 1940

**The Lighthouse at Two Lights**
1929
oil on canvas
74.9 × 109.8 cm.
© 1989 by The Metropolitan
Museum of Art, New York
Hugo Kastor Fund, 1962 (62.95)

**Early Sunday Morning**
1930
oil on canvas
89 × 152.4 cm.
The Whitney Museum of
American Art, New York
Purchase, with funds from
Gertrude Vanderbilt, 31.426

**Tables for Ladies**
1930
oil on canvas
122.5 × 153 cm.
© 1989 by The Metropolitan
Museum of Art, New York
George A. Hearn Fund, 1931
(31.62)

**New York, New Haven and
Hartford**
1931
oil on canvas
81.2 × 127 cm.
© Indianapolis Museum of Art
The Emma Harter Sweetser Fund

**Hotel Room**
1931
oil on canvas
152.4 × 165.7 cm.
Thyssen-Bornemisza Collection,
Lugano, Switzerland

**Dauphinée House***
1932
oil on canvas
86.4 × 127.6 cm.
Courtesy ACA Galleries, New York
and Gerald Pictures Gallery,
Santa Fe, New Mexico
Photo ACA Galleries/Carl Andrews

**Shakespeare at Dusk***
1935
oil on canvas
43.2 × 63.6 cm.
The Lobell Family Collection

**House at Dusk***
1935
oil on canvas
92 × 127 cm.
Virginia Museum of Fine Arts,
Richmond, Virginia
The John Barton Payne Fund, 1953

**Macomb's Dam Bridge***
1935
oil on canvas
88.9 × 152.8 cm.
The Brooklyn Museum,
Brooklyn, New York
Bequest of Miss Mary T. Cockcroft
57.145

**Ground Swell***
1939
oil on canvas
91.4 × 127 cm.

Collection of the Corcoran Gallery
of Art, Washington, D.C.
Museum Purchase,
William A. Clark Fund, 1943

**Cape Cod Evening***
1939
oil on canvas
76.8 × 102.2 cm.
National Gallery of Art,
Washington, D.C.
John Hay Whitney Collection
1982.76.6

**New York Movie***
1939
oil on canvas
81.9 × 101.9 cm.
The Museum of Modern Art,
New York
Given anonymously, 1941

**Office at Night***
1940
oil on canvas
56.2 × 63.5 cm.
Walker Art Center,
Minneapolis, Minnesota
Gift of the T. B. Walker
Foundation
Gilbert M. Walker Fund, 1948

**Nighthawks**
1942
oil on canvas
76.2 × 144 cm.
© 1989, The Art Institute
of Chicago, Chicago
Friends of American Art Collection
1942.51

**Dawn in Pennsylvania***
1942
oil on canvas
62.2 × 113 cm.
Terra Museum of American Art,
Chicago
Daniel J. Terra Collection

**Summertime**
1943
oil on canvas
74 × 111.8 cm.
Delaware Art Museum,
Wilmington, Delaware
Gift of Dora Sexton Brown

**Morning in a City***
1944
oil on canvas
111.8 × 152.4 cm.
Williams College Museum of
Art,
Williamstown, Massachusetts
Bequest of Lawrence J. Bloedel,
23

**August in the City***
1945
oil on canvas
58.4 × 76.7 cm.
Norton Gallery of Art,
West Palm Beach, Florida

**Rooms for Tourists***
1945
oil on canvas
76.8 × 107 cm.
Yale University Art Gallery,
New Haven, Connecticut
Bequest of Stephen Carlton
Clark
B.A., 1903

**Pennsylvania Coal Town***
1947
oil on canvas mounted on
hardboard
71.1 × 101.6 cm.
The Butler Institute of American
Art, Youngstown, Ohio

**Summer Evening**
1947
oil on canvas
74 × 111.8 cm.
Collection of
Mr. and Mrs. Gilbert H. Kinney
Washington, D.C.

**Seven A.M.**
1948
oil on canvas
76.2 × 102 cm.
The Whitney Museum of
American Art, New York
Purchase and exchange. 50.8

**Conference at Night**
1949
oil on canvas
70.5 × 101.6 cm.

Collection Wichita Art Museum,
Wichita, Kansas

**High Noon**
1949
oil on canvas
69.8 × 100.3 cm.
The Dayton Art Institute,
Dayton, Ohio
Gift of Mr. and Mrs. Anthony
Haswell

**Rooms by the Sea**
1951
oil on canvas
73.7 × 101.6 cm.
Yale University Art Gallery,
New Haven, Connecticut
Bequest of Stephen Carlton
Clark

**Hotel by a Railroad***
1952
oil on canvas
72.2 × 101.8 cm.
The Hirshhorn Museum and
Sculpture Garden,
Smithsonian Institution,
Washington, D.C.
Gift of Joseph H. Hirshhorn
Foundation, 1966

**Morning Sun*** \
1952
oil on canvas
71.4 × 101.9 cm.
The Columbus Museum of Art,
Columbus, Ohio
Museum Purchase:
Howald Fund Purchase

**Office in a Small City***
1953
oil on canvas
71.7 × 101.6 cm.
© 1989 by The Metropolitan
Museum of Art, New York
George A. Hearn Fund

**Carolina Morning**
1955
oil on canvas
76.2 × 102 cm.
The Whitney Museum of
American Art, New York
Given in memory of Otto L.
Spaeth by his family. 67.13

**Four Lane Road**
1956
oil on canvas
69.8 × 105.4 cm.
Private collection
Courtesy of Hirschl and Adler
Galleries, New York

**People in the Sun***
1960
oil on canvas
102.6 × 153.5 cm.
The National Museum of
American Art,
Smithsonian Institution,
Washington, D.C.
Gift of S. C. Johnson and Son, Inc.

**New York Office**
1962
oil on canvas
101.6 × 139.7 cm.
Montgomery Museum of Fine Arts,
Montgomery, Alabama
The Blount Collection of American
Art

## Watercolors

**The Mansard Roof***
1923
watercolor over pencil on paper
35.5 × 50.8 cm.
The Brooklyn Museum,
Brooklyn, New York
Museum Collection Fund. 23.100

**Saint Michael's College, Santa Fe***
1925
watercolor on paper
35.24 × 50.64 cm.
The Whitney Museum of
American Art, New York
Josephine N. Hopper Bequest
70.1158

**Barn and Silo, Vermont***
1927
watercolor on paper
35.2 × 50.5 cm.
The Metropolitan Museum of Art,
New York
The Lesley and Emma Sheafer
Collection of Emma A. Sheafer,
1973

**House of the Fog Horn 1***
1927
watercolor over pencil on paper
35.8 × 50.6 cm.
The Metropolitan Museum of Art,
New York
Bequest of Elisabeth Amix
Cameron Blanchard
(Mrs. J. O. Blanchard), 1956

**Saltillo Mansion***
1943
watercolor on paper
54 × 68.6 cm.
The Metropolitan Museum of Art,
New York
George A. Hearn Fund, 1945

**Coast Guard Station, Two Lights, Maine***
watercolor on paper
35.2 × 50.5 cm.
The Metropolitan Museum of Art,
New York
The Lesley and Emma Sheafer
Collection
Bequest of Emma A. Sheafer, 1973

**Victorian House***
watercolor on paper
35.24 × 50.48 cm.
The Whitney Museum of
American Art, New York
Josephine N. Hopper Bequest
70.1432

**Jo Sketching at the Beach***
watercolor on paper
35.24 × 50.8 cm.
The Whitney Museum of
American Art, New York
Josephine N. Hopper Bequest
70.1129

## Drawings

Drawing for etching
**East Side Interior***
1922
black Conté crayon and charcoal
on paper
22.7 × 29.21 cm.
The Whitney Museum of
American Art, New York
Josephine N. Hopper Bequest
70.342

Drawing for painting
**Macomb's Dam Bridge***
1935
black Conté crayon on paper
22.8 × 59.7 cm.
The Whitney Museum of
American Art, New York
Josephine N. Hopper Bequest
70.440
(not reproduced)

Drawing for painting
**Cape Cod Evening***
1939
black Conté crayon on paper
21.6 × 27.9 cm.
The Whitney Museum of
American Art, New York
Josephine N. Hopper Bequest
70.183

Drawing for painting
**Office at Night No. 2***
1940
black Conté crayon and charcoal
with touches of white on paper
38.42 × 46.67 cm.
The Whitney Museum of
American Art, New York
Josephine N. Hopper Bequest
70.341

Drawing for painting
**Morning in a City***
1944
black Conté crayon on paper
21.6 × 27.9 cm.
The Whitney Museum of
American Art, New York
Josephine N. Hopper Bequest
70.207

Drawing for painting
**August in the City***
1945
black Conté crayon on paper
21.6 × 27.9 cm.
The Whitney Museum of
American Art, New York
Josephine N. Hopper Bequest
70.456
(not reproduced)

Drawing for painting
**Pennsylvania Coal Town***
1947
black Conté crayon on paper
28.26 × 38.1 cm.
The Whitney Museum of
American Art, New York
Josephine N. Hopper Bequest
70.229

Drawing for painting
**Hotel by a Railroad***
1952
black Conté crayon on paper
48.3 × 30.4 cm.
The Whitney Museum of
American Art, New York
Josephine N. Hopper Bequest
70.427

Drawing for painting
**Morning Sun***
1952
black Conté crayon on paper
30.5 × 48.3 cm.
The Whitney Museum of
American Art, New York
Josephine N. Hopper Bequest
70.244
(not reproduced)

Drawing for painting
**Sun in an Empty Room***
c. 1963
charcoal on beige paper
31 × 37.8 cm.
Musée Cantini, Marseilles
Acquired in 1988

## Prints

**Les Poilus***
1915-1918
etching
23.5 × 26 cm.
The Philadelphia Museum of Art,
Philadelphia
Thomas Skelton Harrison Fund

**Train and Bathers***
1920
etching
34.45 × 38.1 cm.
The Whitney Museum of
American Art, New York
Josephine N. Hopper Bequest
70.1055

**American Landscape***
1920
etching
35.08 × 46.36 cm.
The Whitney Museum of
American Art, New York
Josephine N. Hopper Bequest
70.1005

**Les Deux Pigeons***
1920
etching
21.2 × 25 cm.
The Museum of Modern Art,
New York
Abby Aldrich Rockefeller Fund.
9754

**Night Shadows***
1921
etching
33.81 × 36.2 cm.
The Whitney Museum of
American Art, New York
Josephine N. Hopper Bequest
70.1048

**Night in the Park***
1921
etching
34.29 × 37.78 cm.
The Whitney Museum of
American Art, New York
Josephine N. Hopper Bequest
70.1046

**Evening Wind***
1921
etching
17.6 × 21.1 cm.

The Museum of Modern Art,
New York
Abby Aldrich Rockefeller Fund.
962.40

**The Cat Boat***
1922
etching
20 × 24.9 cm.
The National Museum of
American Art,
Smithsonian Institution,
Washington, D.C.

**Girl on a Bridge***
1922
etching
32.54 × 38.26 cm.
The Whitney Museum of
American Art, New York
Josephine N. Hopper Bequest
70.1023

**East Side Interior***
1922
etching
34.29 × 45.72 cm.
The Whitney Museum of
American Art, New York
Josephine N. Hopper Bequest
70.1020

**The Locomotive***
1923
etching
34.61 × 40.96 cm.
The Whitney Museum of
American Art, New York
Purchase 31692

**Aux Fortifications***
1923
etching
30.1 × 37.8 cm.
The Museum of Modern Art,
New York
Mr. and Mrs. E. Powis Jones
Fund
62259

**The Balcony***
1928
drypoint
33.02 × 43.18 cm.
The Whitney Museum of
American Art, New York
Josephine N. Hopper Bequest
70.1058